Flight
of Spirit

(MYSELF AS) MARILYN MONROE, n.d.

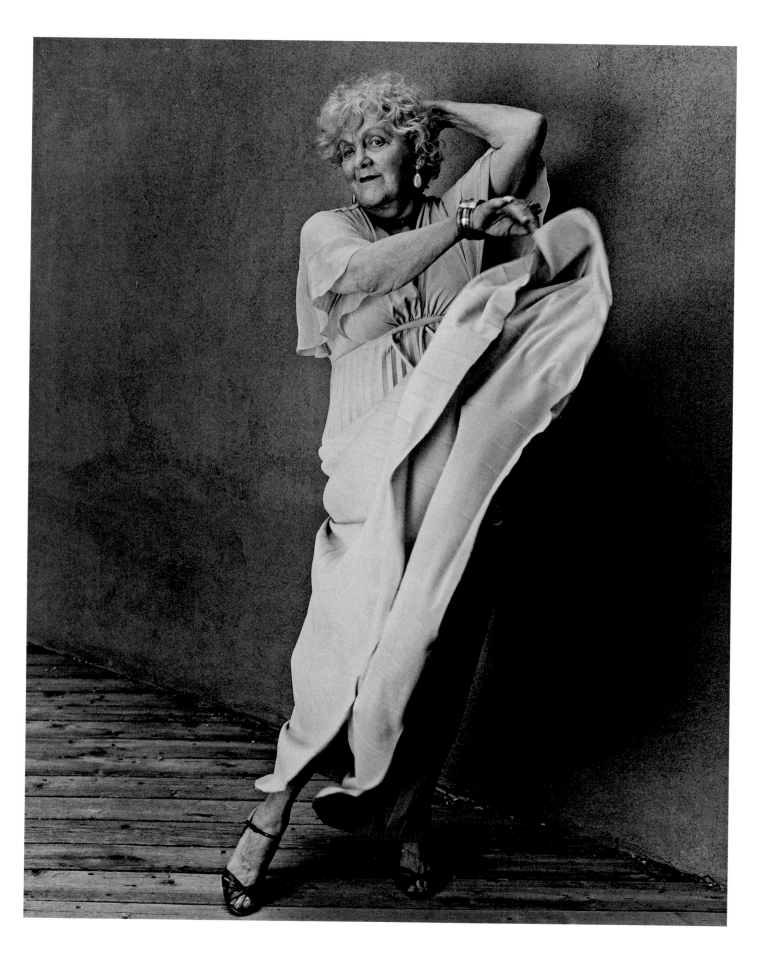

Flight of Spirit

The Photographs of Anne Noggle

Edited by Martha A. Strawn

Foreword by Lucy R. Lippard

Essay by Lili Corbus

MUSEUM OF NEW MEXICO PRESS
SANTA FE

For Anne Noggle

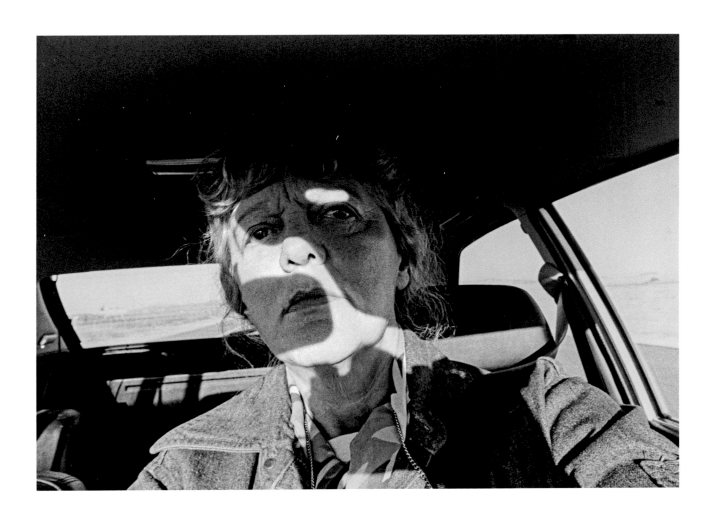

SELF-PORTRAIT, 1979

9

PREFACE Flight of Spirit

Anne Noggle was an ardent aviator, a member of the Women Airforce Service Pilots (WASP) in World War II. She served in the US Air Force during the Korean War, and after the wars she was a stunt and crop-dusting pilot in Texas. When she no longer flew for a living, she went back to school to engage her creative intelligence. She became a photographer who made magnificently expressive portraits of herself and others in the context of their living environments; her spirit and zest for life shone through her endeavors.

The Anne Noggle Foundation (ANF) in conjunction with the Museum of New Mexico Press (MNMP) is delighted to present a selection of Anne's work chosen from her archive at the Harry Ransom Center, The University of Texas at Austin, and from the Anne Noggle Foundation Collection, with a foreword by Lucy R. Lippard (writer, art critic, activist, and curator) and a critical essay by Lili Corbus (art and photographic historian).

As president of the Anne Noggle Foundation and a personal friend and colleague of Anne's for many years before she died, I am honored to present this book for the ANF and the MNMP. Anne's enthusiasm for photographing, writing poetry, studying Russian literature, and playing pool and her overall exuberance about life were contagious. Her photographs tell of her relationships with self and others. At once poignant, intense, and humorous, and always revealing their subject, they also provide wise commentary on the surrounding culture.

I met Anne as a colleague on the Society for Photographic Education (SPE) Board of Directors. We were assigned a room together in a Chicago airport hotel. From airport to airport and on to the hotel, neither of us had had a breath of fresh air, and both of us were feeling suffocated. We took one look at each other and ordered two gin and tonics, pronto, vowing that we would survive a weekend of SPE bylaw revisions and get ourselves home again, both of us having at least made a new friend. That began a thirty-year friendship.

Anne's photographic career spanned forty years and included exhibitions in the United States and abroad. She also produced three books of her work, which reflect her focus on self and relationships and on women pilots. Upon receiving her first National Endowment for the Arts Photography Fellowship in 1975, Anne set a precedent—using self-portraits of her body and her facelifts to contemplate aging directly. In exhibitions these photographs

especially drew women, both younger and older, to express gratitude for seeing pictures that mirrored their own feelings.

The Anne Noggle Foundation was established after Noggle's death to distribute her work and highlight her relevance and continuing importance in the world of image making. Her three books are *Silver Lining: Photographs by Anne Noggle* (foreword by Van Deren Coke and text by Janice Zita Grover), University of New Mexico Press, 1983; *For God, Country, and the Thrill of It: Women Airforce Service Pilots in World War II* (photographic portraits and text by Anne Noggle, introduction by Dora Dougherty Strother), Texas A&M University Press, 1990; and *A Dance with Death: Soviet Airwomen in World War II* (text and contemporary portraits by Anne Noggle and introduction by Christine A. White), Texas A&M University Press, 1994. These books provide an in-depth vision of Anne's photographic interests and her commitment to honor women serving in the military. Anne believed women were entirely capable of functioning in all aspects of life.

As editor, I have drawn on my personal knowledge of Anne's life and her professional goals. For this book I used the three books cited above, the Anne Noggle Collection (owned by the Anne Noggle Foundation), her archive at the University of Texas Harry Ransom Center, and information solicited from Anne's friends and colleagues. Lucy R. Lippard graciously wrote the foreword and Lili Corbus undertook the critical essay. Our overview of Anne's work positions her securely in the history of photography.

An independent woman who lived life fully, Anne Noggle was a model of creative persistence. She encouraged students, friends, and colleagues (female and male) in creative achievements and urged them to accept leadership roles. She also encouraged others to trust their abilities, to have fun, to play and work hard, to continue learning, to use their intelligence consistently, while being generous materially and emotionally. Anne expressed her vitality and richness of soul in her images.

The photographs in this book and the texts accompanying those images will demonstrate all I have described. Anne was a BIG PERSON in heart and spirit. Her lovely gentleness was balanced by her feisty toughness. She loved glitter makeup and besting her opponent in a game! Her character was fun-loving with a backdrop of philosophy and depth of soul. We at the Anne Noggle Foundation and at the Museum of New Mexico Press hope that you enjoy this flight through her pictures and that when you have finished, you land with the joy of enrichment.

Martha A. Strawn
President, Anne Noggle Foundation

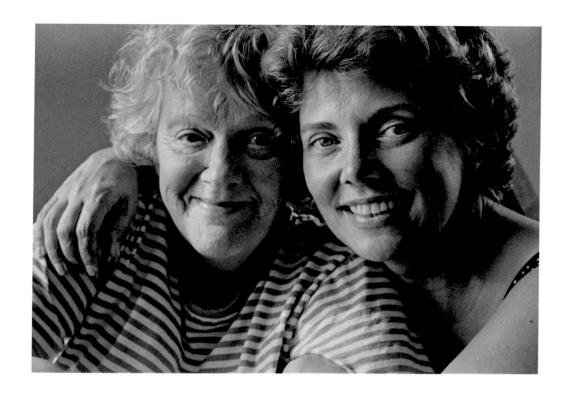

Anne Noggle and Martha A. Strawn, photograph by Evon Streetman, ca. 1985

Sketch for a self-portrait

Where are you tonight while the sky reflects my solitary presence.
Where are you now those of you that might whisper I love you,
Are you in a watery grave down under the sea with a picture of me smiling in a hip pocket.
Where did all the promise go where did all the friends go. Have we dissolved into the past,
Are we granny or auntie or that old lady down the street. I have lost my way
And my face reminds me of that. Every Stop and Start, love and loss legible.
A whole individual story and who will read it.
Who will look at my face and find me there?

Anne Noggle, 1982

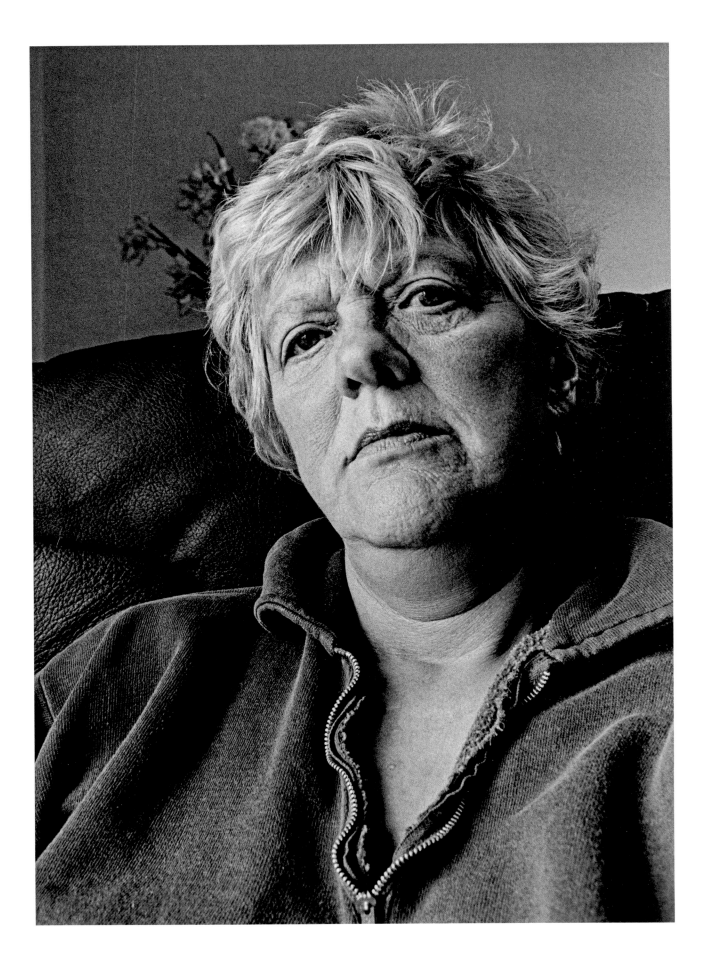

"Wild-Ass" Messages from Within

Lucy R. Lippard

"Look at me/Riding through eternity."
—ANNE NOGGLE, "SKY HIGH"

Anne Noggle's first love was flying, not photography, although mastery of delicate machines and a certain level of danger—physical and emotional—have fueled all her work. The title of her book *For God, Country, and the Thrill of It* says it all. Being a female air force pilot during World War II meant becoming one of the boys. (Thirty-eight women died in flight. Despite their exploits, they were always called girls; one of their planes was dubbed *Ladybird*, long before the First Lady or the film.) When Noggle followed up that collection of portraits of her companions in the WASP with the amazing first-person chronicles of *A Dance with Death: Soviet Airwomen in World War II*, it became clear that these experiences were the most satisfying and thrilling of her life. While she eventually became a respected photographer and university professor, it was her own dances with death that continued to inform her art. (See portfolios III and IV.)

Living in Paris after being grounded from aviation and before she had discovered photography, "Capitaine Noggle" pondered her youth in the military, then as crop duster, flight instructor, and performer in an aerial circus: "If I had been a man flying in those days, I would have been described as a wild-ass. . . . Flying is for the young to do and the middle-aged to dream about."[1] Of the resemblance between flying and photography, she wrote: "Both are done alone . . . and both require independence and optimism and some dumb courage."[2] She also likened photography to poetry: "It is whatever is inside that demands to be seen."[3] In 1970, when she was forty-eight years old, Noggle reflected on her dual careers, writing in her poem "Sky High": "I watch the high/playful/arc of sunlight/dance/across the canopy of my mind./And even as I sense there is something to be known/it dissolves/like logic unraveling in a dream." This is also an apt description of the photographic process.

My first exposure to Noggle's work was during the heyday of "second-wave feminism" in the 1970s. Her 1977 photograph *Stonehenge Decoded* is extraordinary in both form and content. To the left is a dramatic southwestern landscape that could have stood on its own. It is, however, overshadowed on the right by the columnar belly, pubis, and thighs of an aging woman, her shirt casually pulled up at the top. The image is unique in

ANNE WITH ZIPPER, n.d.

19

its combination of strength and vulnerability. Its strength lies in the solidity, the fearless exposure of aging flesh, and the way it fills an entire third of the image, top to bottom. The vulnerability lies not only in the proud display of an unconventionally worn female body, but also in its placement in a darkening, challengingly open land, volcanic cones visible in the distance, dark clouds overhead. Like a defiant archaeological remnant, Noggle's own body stands in for eons of female time and experience. (See p. 103.)

As she began to live as an artist, within the visual, Noggle realized, "How I *look* has affected how I *feel* about myself." This was a poignant revelation. Just as feminism was gaining ground, many women artists were beginning to confront issues of vanity, vulnerability, and social expectations. Conceptual and performance artists like Martha Wilson and Adrian Piper were using photography in unconventional ways. During that fertile moment of creativity, as women reclaimed their places in the art hierarchies, Noggle's *Facelift Series* also became iconic. Once again, a trenchant commentary—this time on society's insistence that women resist natural aging. In 1980 she photographed her sister and herself with both hands "lifting" their faces in wishful defiance of sagging features. (See p. 29.) (I suspect every woman has tried this at some point; I know I have.) By that time Noggle herself had already had surgery five years earlier and had made unflinching photographs of herself before (*Self-portrait, Before Surgery*) and after. "If I am shown in my face-lift as attempting to stave off the visible aging process," she wrote ruefully, "it is also an indication of what an exercise in futility that is."[4] (See p. 105.) In *Face lift No. 3*, she holds a rose in her mouth (definitely not "in her teeth," although she may have intended it as an ironic reference to that dated brand of glamor); in the background are a rosebush and a model airplane. Her expression is pensive, as though she is perhaps having second thoughts about the role of nature, and about youth. (See p. 107.)

I know of no other photographer who has used self-portraiture so extensively and so powerfully. In her photographic mirror, Noggle is sexy, wistful, coy, sad, mischievous, or trying on various personas (including a man). She is naked up close or distanced, at the wheel of her car driving through the Southwest, under water, flying a small plane, contemplating the ripped shoulder of a shirt, or sitting in bleakly stunning landscapes. Many of these photographs are contemplative, and even border on miserable, but one from 1982 shows the artist at the wheel of her car with a glint in her eye and a triumphant grin on her face: *Myself as a Guggenheim Fellow.* (See p. 101.) Vanity is certainly not an impetus—these are not "selfies." Noggle used her self "universally," exploring emotions by seeing herself as a catalyst for seeing others. She defined portraits as "a slice of mortality . . . a way of saying *Remember Me*"—the theme song of a film on her work.[5] (See pgs. 3, 9, and portfolio V.)

Studying in Albuquerque, New Mexico, twenty years older than her fellow students, Noggle was on the peripheries, which allowed a freedom she used to great advantage. In the late 1960s, photography was not yet considered an "art," and few women photographers were well known. Among the exceptions were Julia Margaret Cameron and especially

Diane Arbus, whose focus on outsiders and unexpected subjects were inspiring.[6] Arbus as a juror awarded one of Noggle's photos a $100 prize when she was still a student, and already, as Janice Zita Grover pointed out, enjoying risks. The impetus to both her careers "was a need to test herself against unknowns, to move beyond convention, to burn her bridges behind her."[7] Certainly her panoramic images of her mother's Santa Fe circle (for instance, a recital in almost Victorian surroundings) in the late 1960s were not the normal fare, nor is the startling beauty of a later image of her mother's gnarled hands holding her dentures. (See p. 42.)

In 1975 Noggle received an NEA grant for "photographing older women in their own homes because they would have an accumulation of belongings and memorabilia that would tell us about them and their culture."[8] (See pgs. 35, 59, 66.) However, that project seems not to have come to fruition. Most of Noggle's later photo portraits, those of the US and Soviet aviators, are taken against a stark, spaceless dark or neutral background that evokes the aura of loneliness or isolation that pervades her work. (See portfolios III and IV.) While her innumerable portraits of others—mostly women—are empathetic, bluntly perceptive, and often even humorous (not mocking, but allowing the sitter's humor to emerge), it is the self-portraits that confirm her originality, displaying what Grover called "the same half-loving, half-cruel curiosity that she employed in photographing others."[9] (She was something of a martinet in posing her subjects.) Artist Know Thyself: setting herself a lifelong task, she was harking to "messages from within."[10]

This pervasive interest in self-image, and perhaps her own mother's aging, led to a broader interest in portraiture. Beginning with people she knew, as her work matured, following "the character of the face . . . and gestures . . . that aliveness in all of us,"[11] Noggle could shift this awareness to people she didn't know. The 1979 *Silver Lining Series* focused on couples, some of whom seem close, others distanced. Noggle acknowledged the rather cynical title: "Its basis is that irony implicit in living together for so long—a double-edged idea that life together is and isn't a bowl of cherries—and trying to indicate it by not giving the answer in the images. I love the enigma of it all."[12]

Although Noggle may have been unaware of it at the time, her passion for exposing the beauty of older women (or as Van Deren Coke put it, "the patina of age as a positive"[13]) was echoed within the feminist community. Athena Tacha began her ongoing exploration of her own aging in a series of tiny artist's books. Later Bailey Doogan's brutally beautiful and disturbing "self-examinations" were described by painter May Stevens (who also confronted her body in later life) as circles "around the life and death drama of bliss and sexual ecstasy tied to a body that is made to age, to rot, to die."[14] I write from twenty-five years in New Mexico,[15] where Noggle spent almost half her life, and now as an octogenarian I can fully identify with her exploration of aging. But I never knew her—not, that is, until I had this chance to spend time with her images, drawn into the circle of bodies and faces and lives portrayed.

PORTFOLIO I

Family

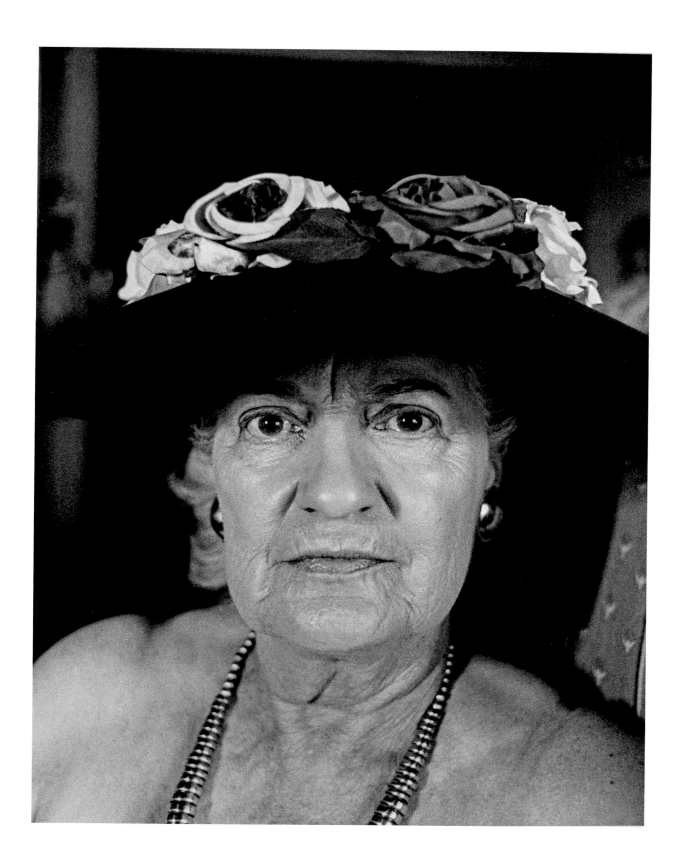

A DESERT BLOOM (sister, Mary), 1987

25

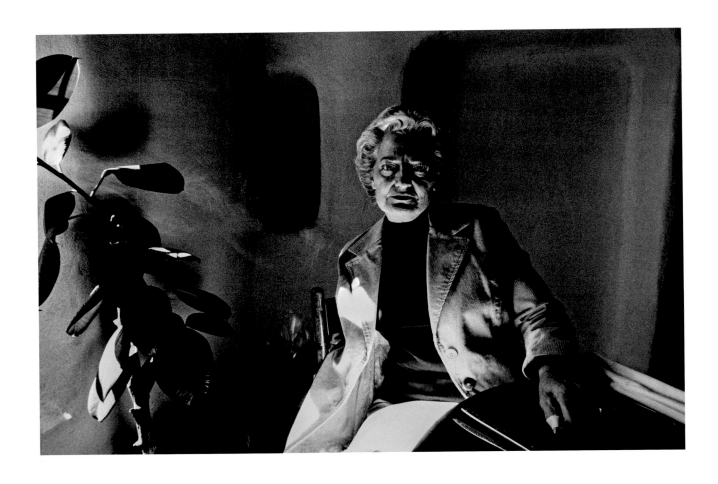

MARY, AFTERNOON NOVEMBER, 1976

26

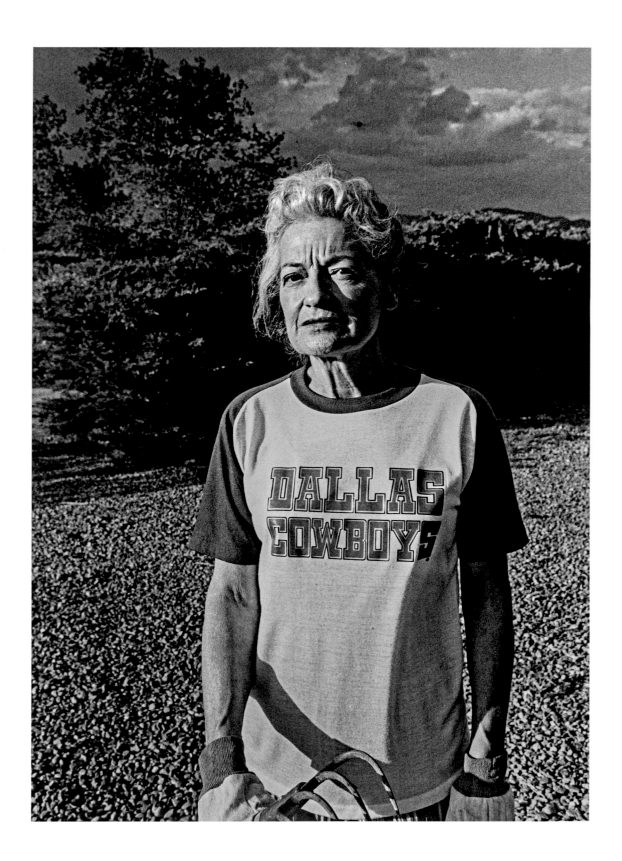

MARY, 1981

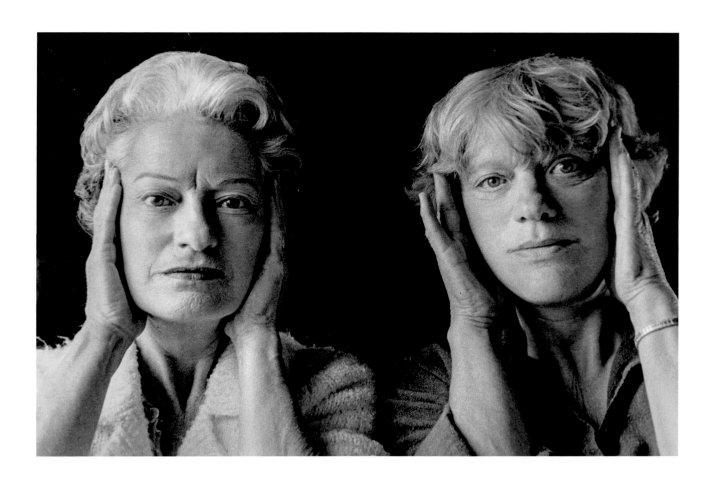

REMININISCENCE: PORTRAIT WITH MY SISTER, 1980

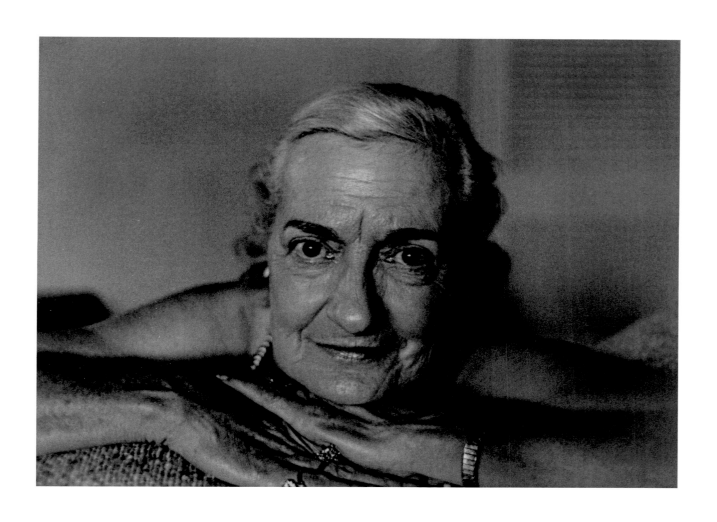

MARY, 1987

31

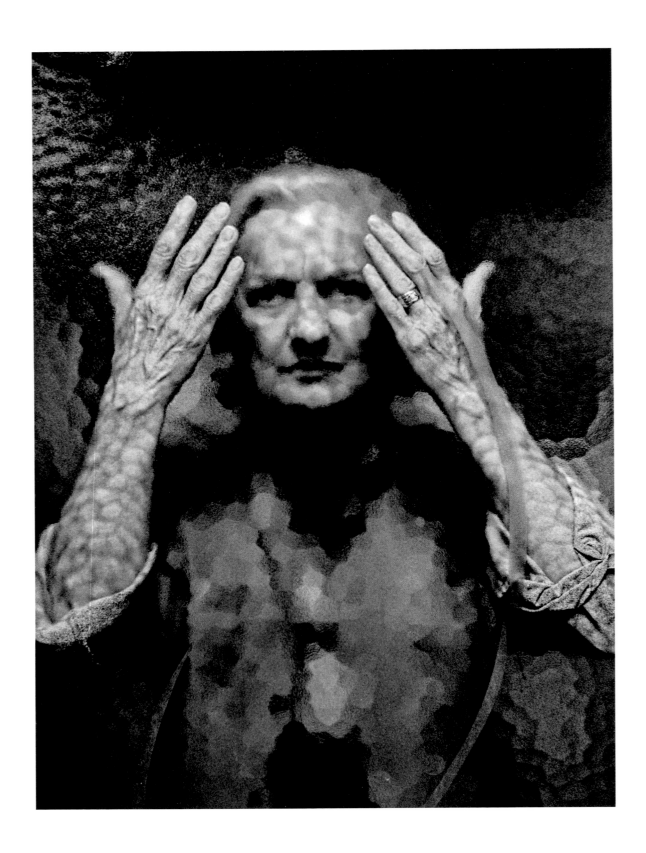

MARY, A RETROSPECTIVE, 1987

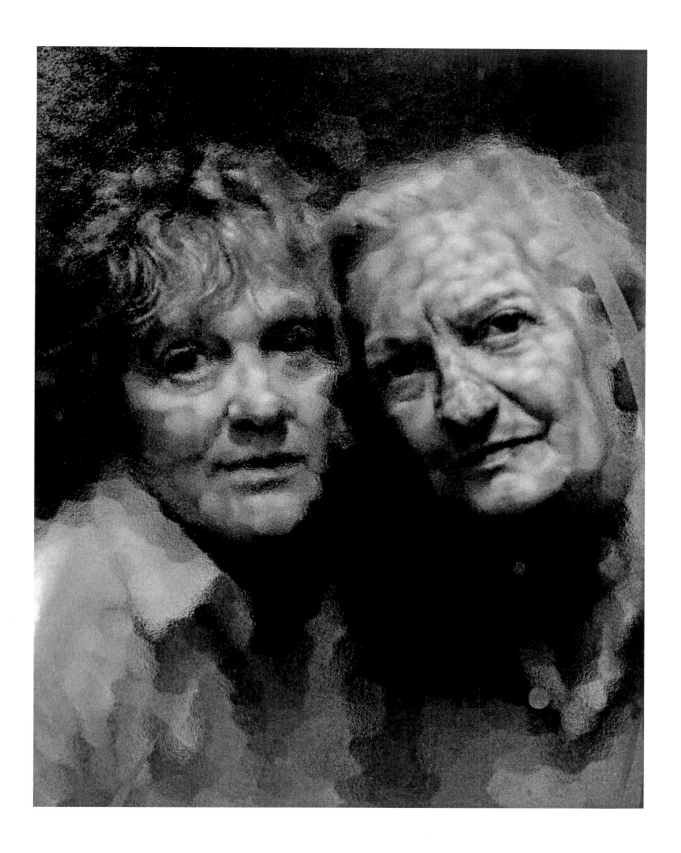

ROMANCING THE PAST, OUTLIVING THE FUTURE, 1987

33

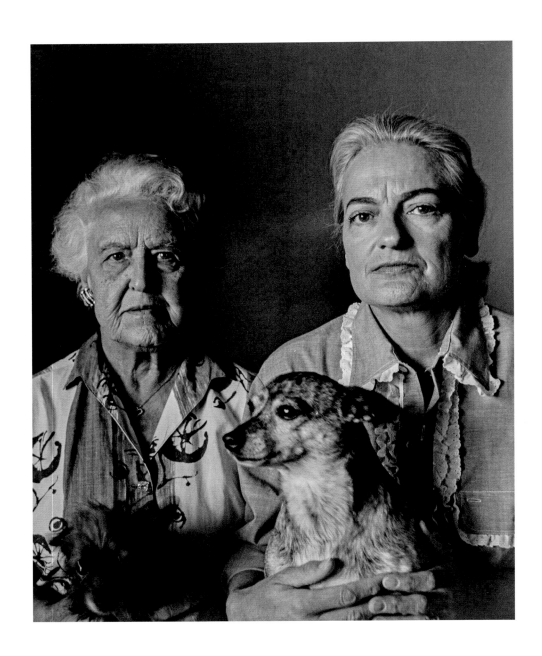

AGNES (mother) AND MARY WITH DOGS, n.d.

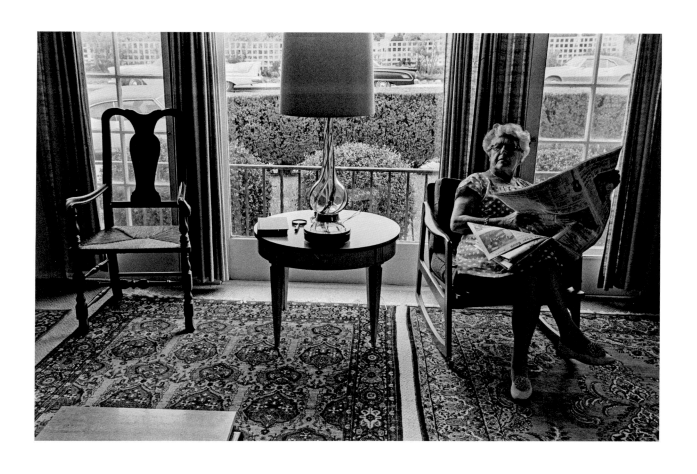

AGNES, LA JOLLA, 1970

35

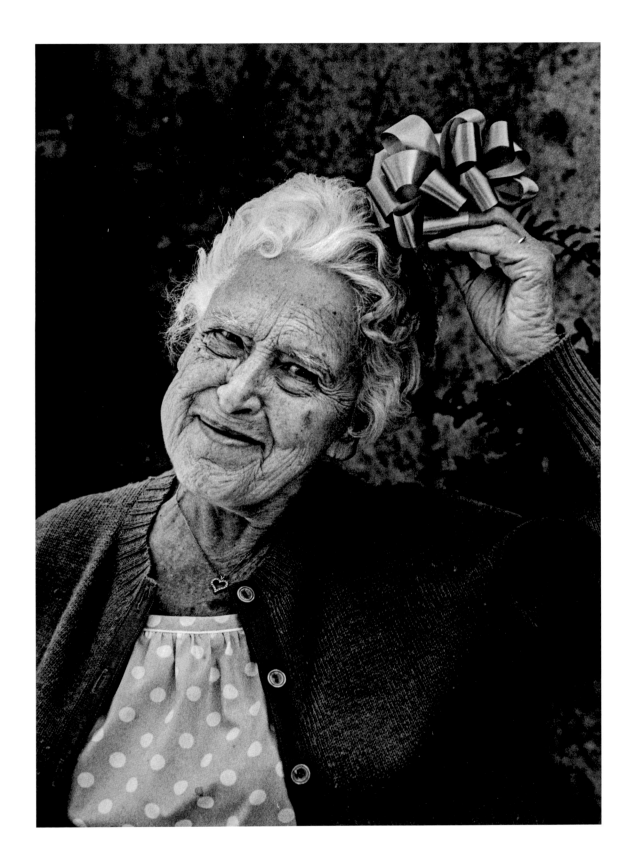

AGNES, 84TH BIRTHDAY (vertical), 1974

37

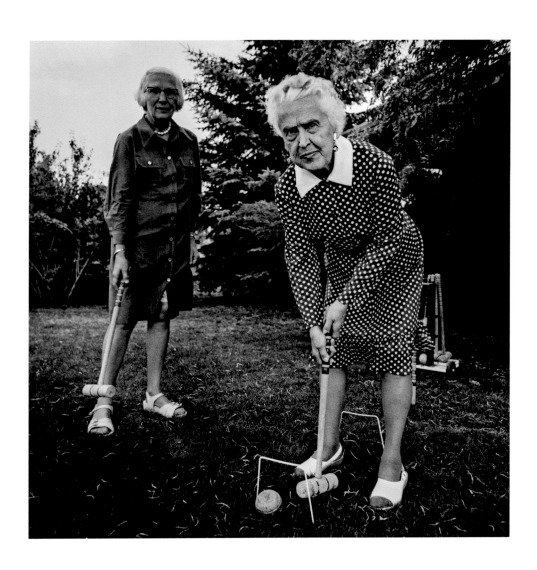

UNTITLED #4 (cousins), 1974–75

39

AGNES, 1976

40

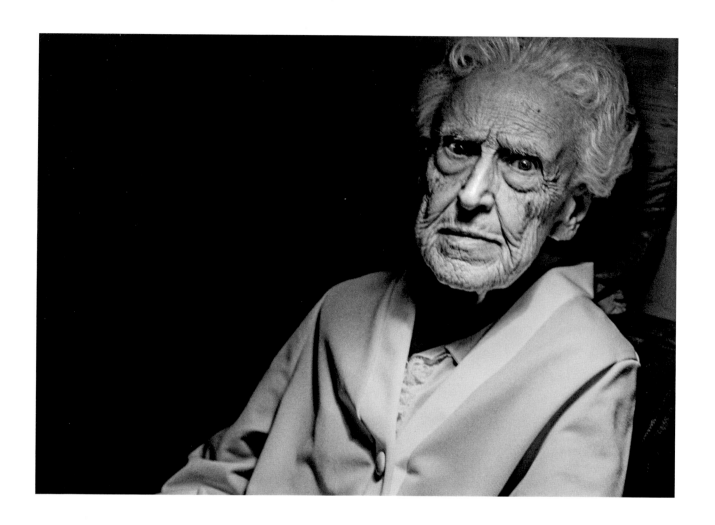

AGNES, 1979

41

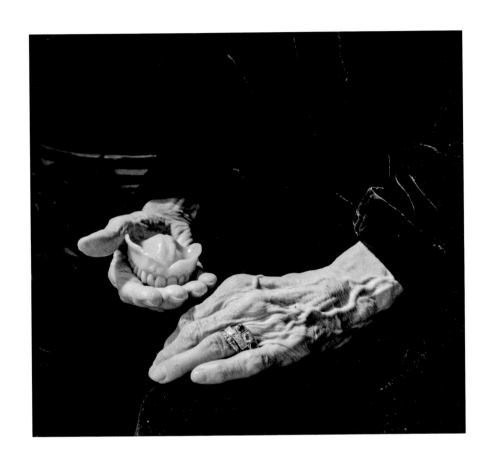

ARTIFACT, 1976

42

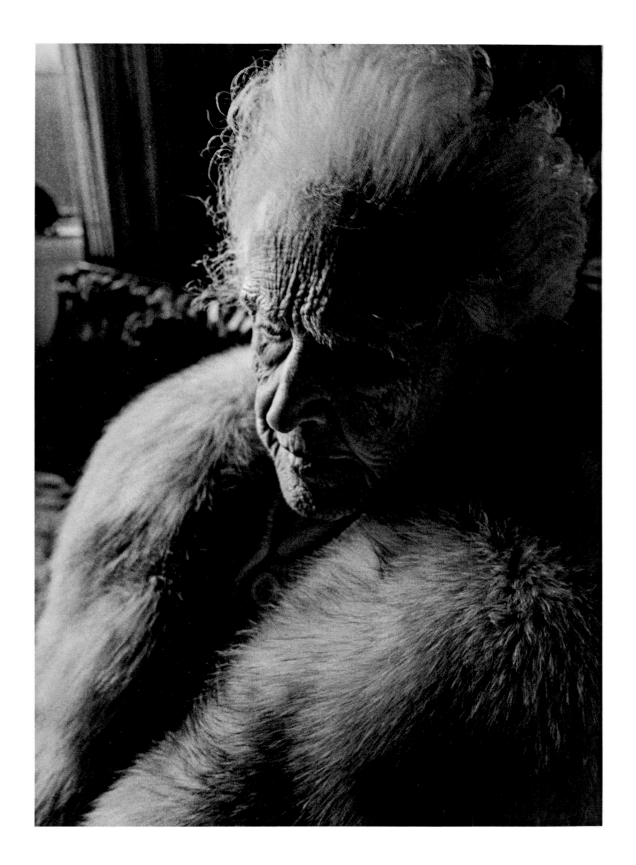

AGNES IN A FUR COLLAR, 1979

43

PORTFOLIO II

Friends

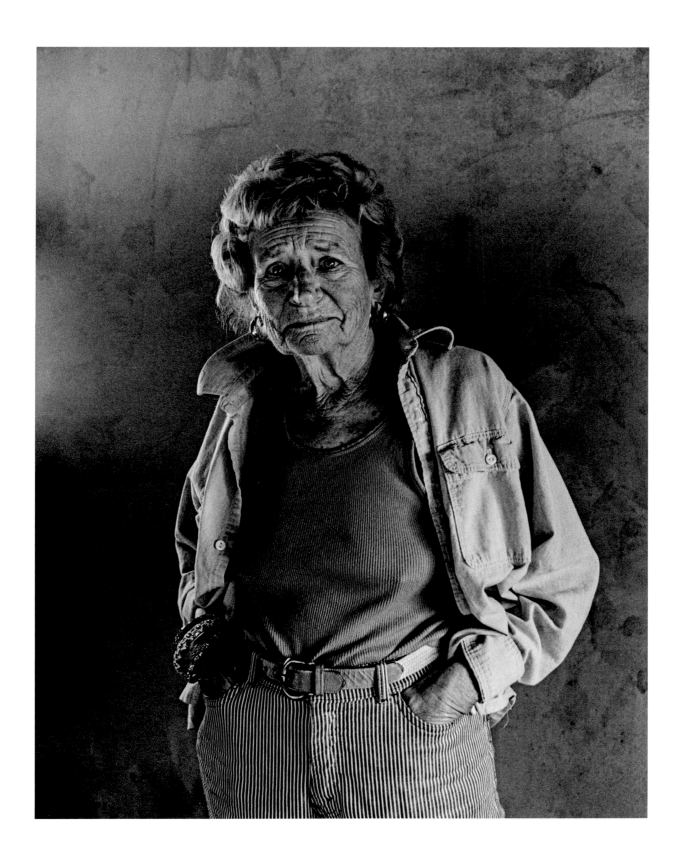

SHELLEY, 1985

47

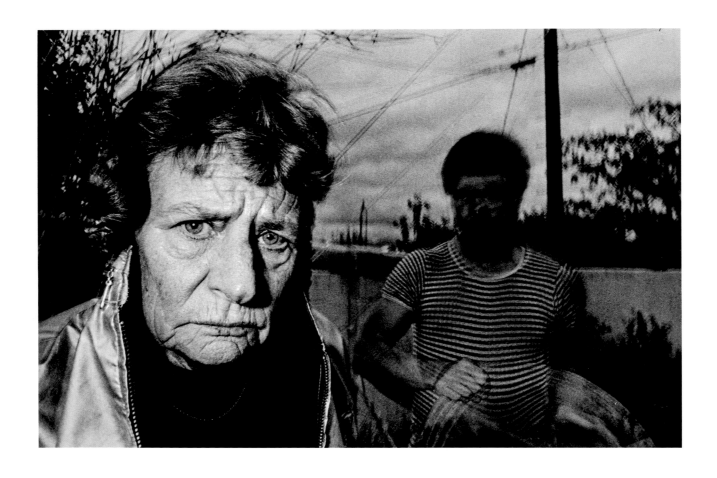

SHELLEY, 1978

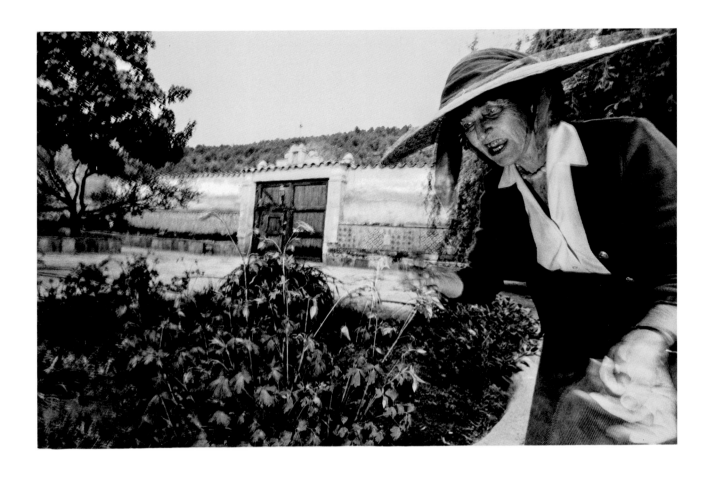

SANTA FE SUMMER NO. 1, 1976

49

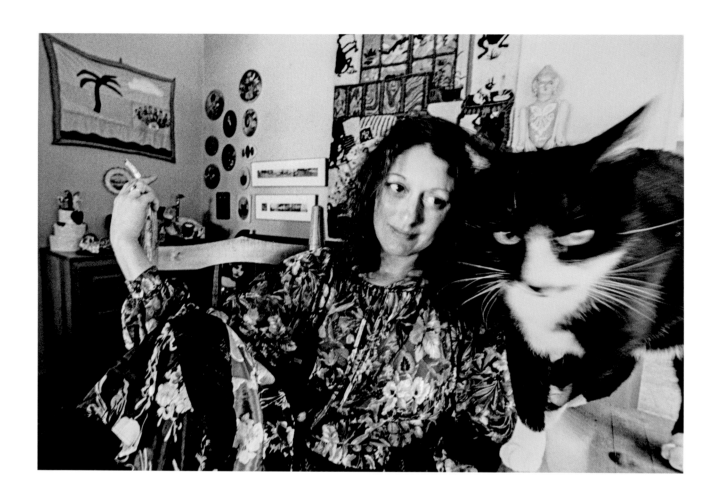

KAREN, 1978

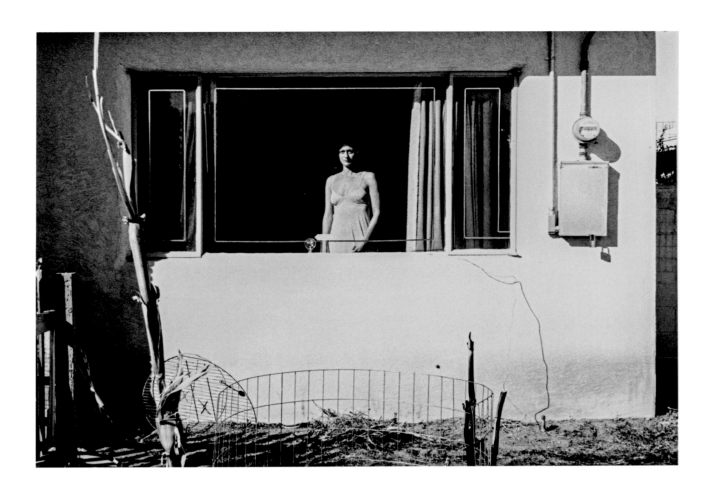

KAREN, WINTER, aka, UNTITLED, 1977

51

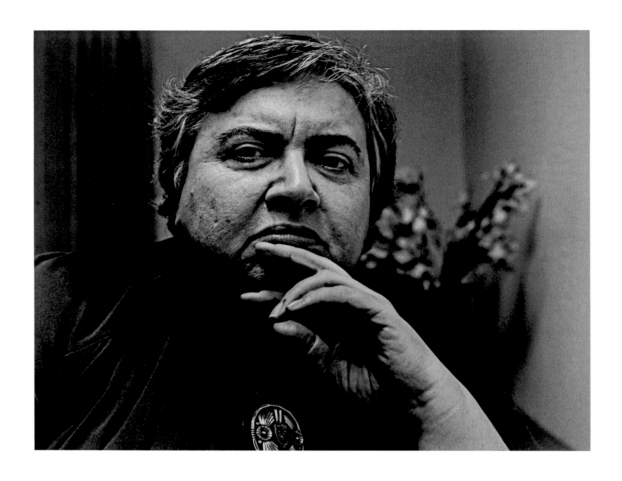

ESTELLE JUSSIM, 1985

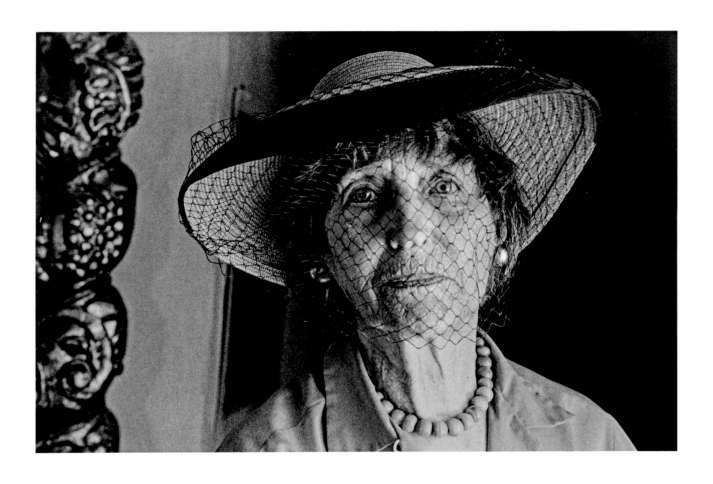

YOLANDA, VEILED IMAGE, 1980

53

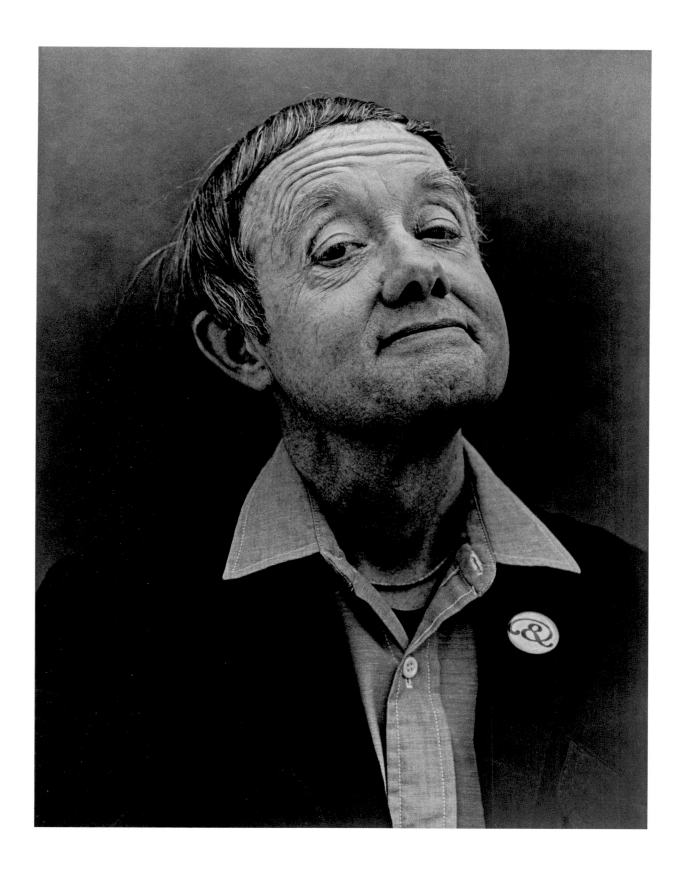

RICHARD RUDISILL, 1986

55

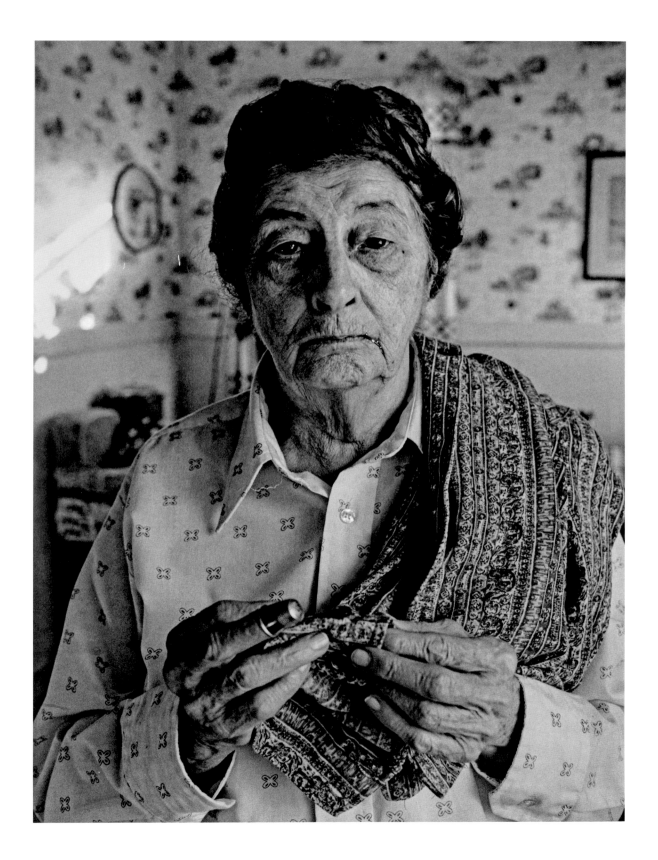

ROSA WILEY, SEAMSTRESS, 1982

57

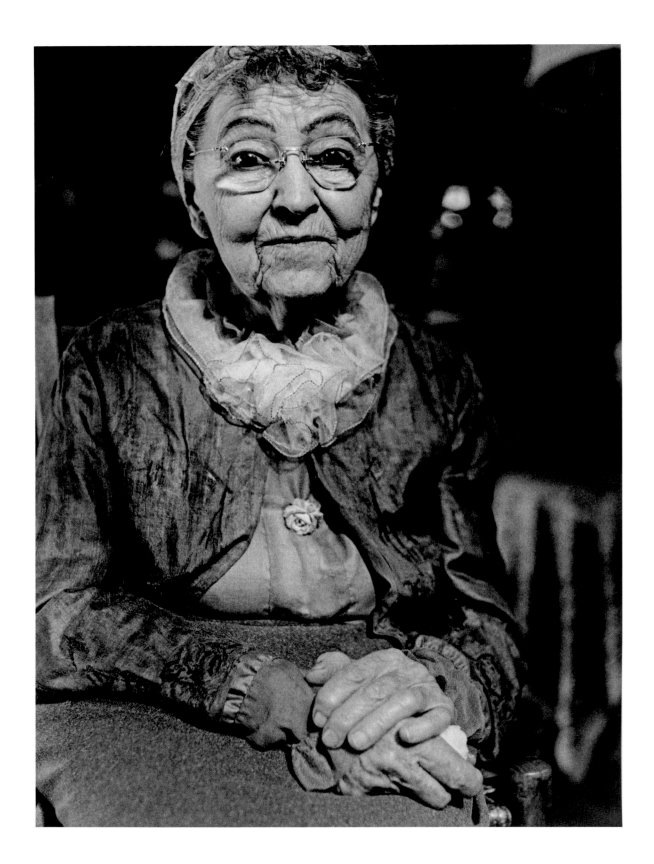

MISS WOYTIC, 1970

58

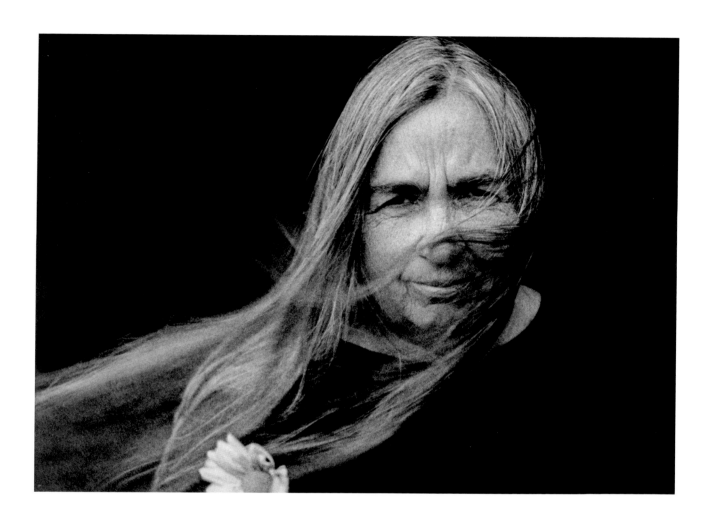

MOTION PICTURE (Martha Barrett), 1989

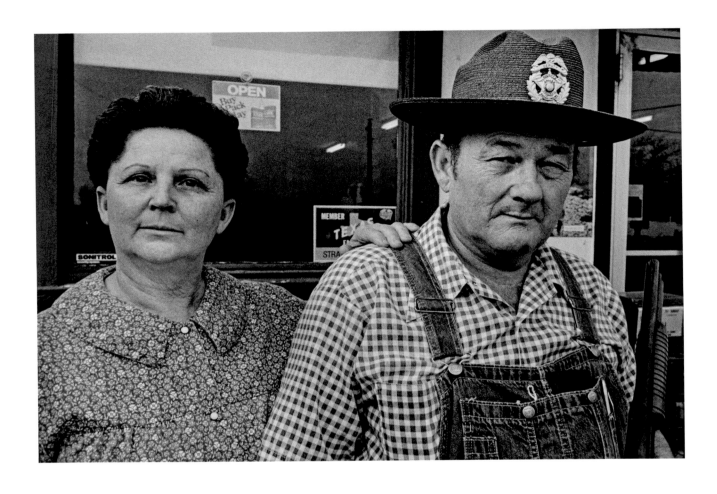

B. J. AND MARY JO GARNER, COMMERCE, TEXAS, 1983

60

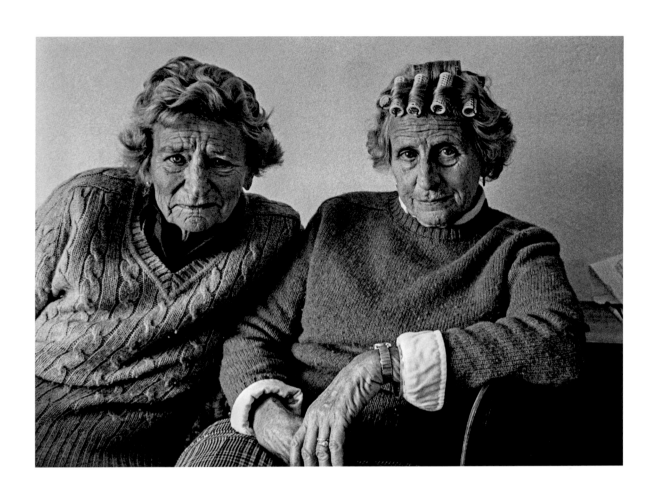

SHELLEY WITH HER SISTER, MIM, 1983

61

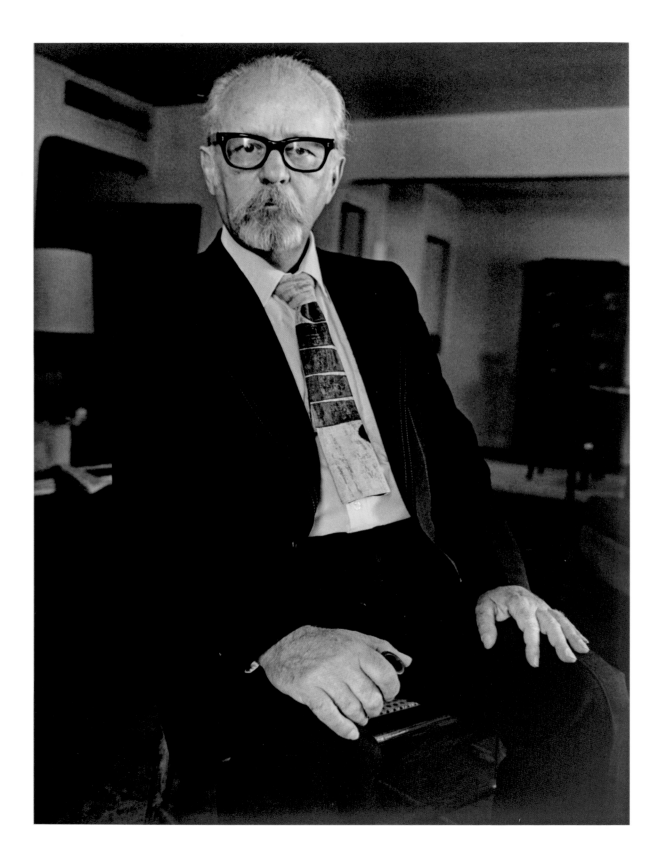

HENRY BUMKIN, DETECTIVE, 1981

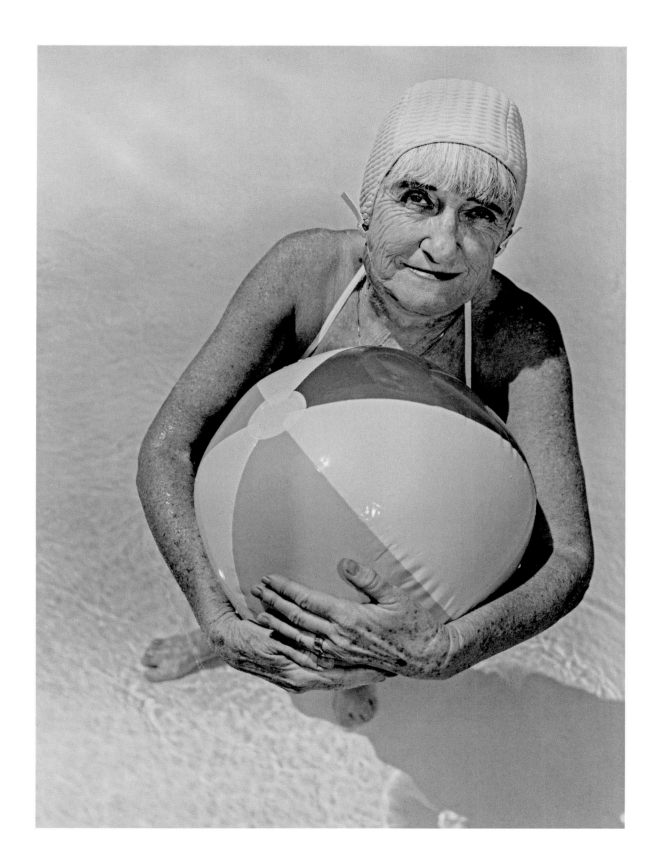

EDITH "TINY" KEENE, 1981

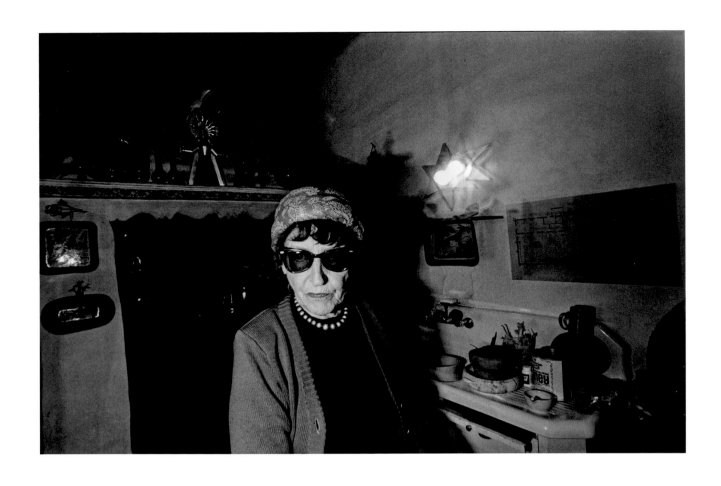

SANTA FE SPRING, 1976

64

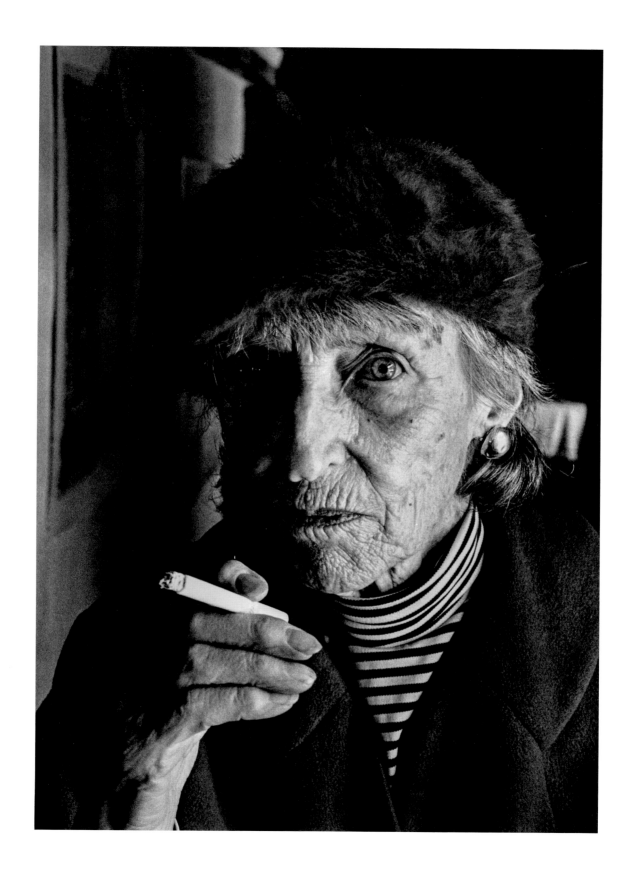

YOLANDA, 1983

65

Sky High

The uncommon grace of it
the bulk and the throb.
Flashing in light
we coat the sky with streamers,
unrolling vapors of graffiti
in mock insolence.
I watch the high,
playful
arc of sunlight
dance
across the canopy of my mind.
And even as I sense there is something to be known
it dissolves
like logic unraveling in a dream.

There is movement
I look up at myself
under the helmet
over the mask
through the goggles.
Look at me
I say
Look at me
Riding through eternity.

Anne Noggle, 1970

PORTFOLIO III

Women Airforce Service Pilots
in World War II

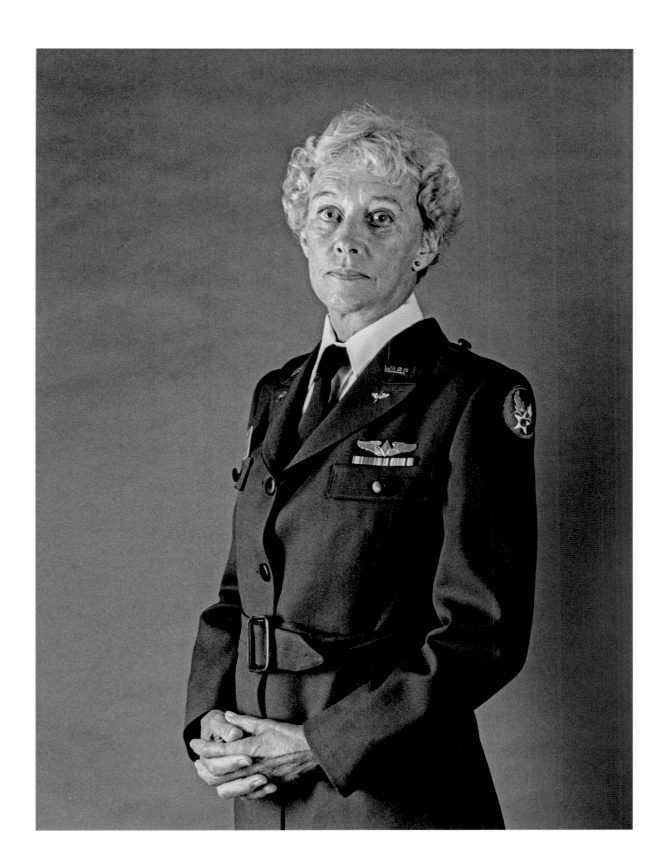

JOAN SMYTHE McKESSON, 1986

71

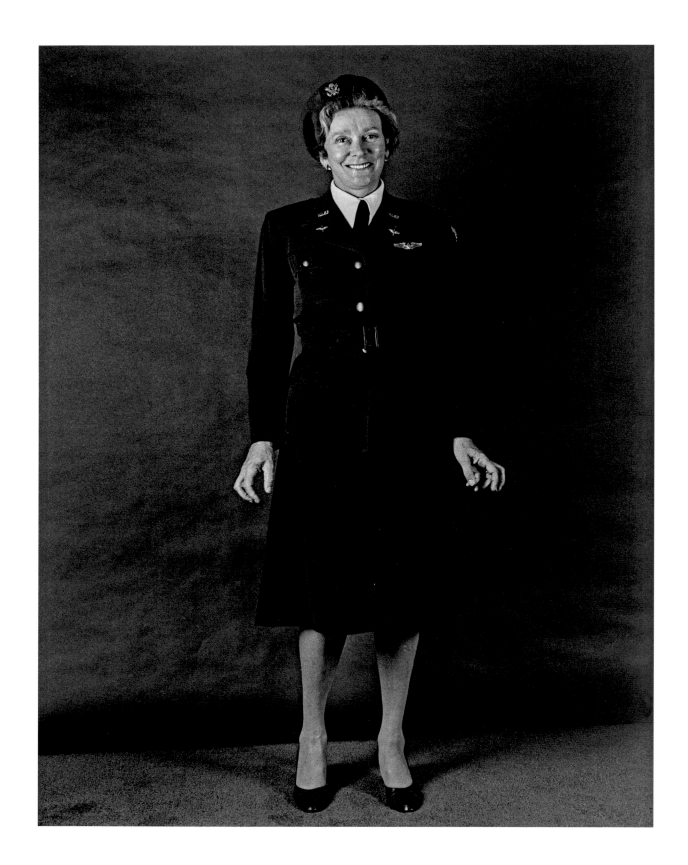

BERNICE FALK HAYDU, 1986

72

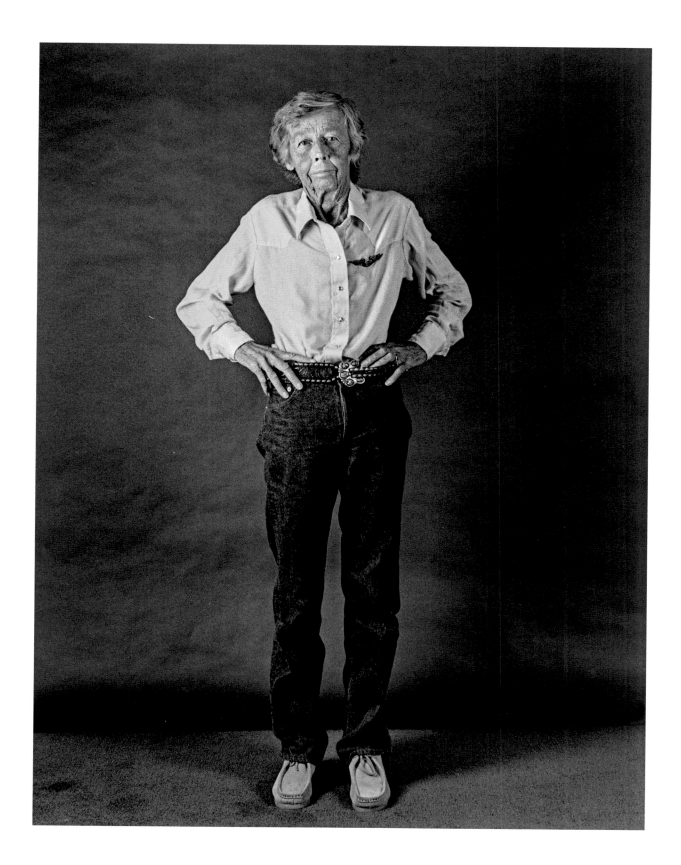

FRANCES THOMPSON HUNT, 1986

73

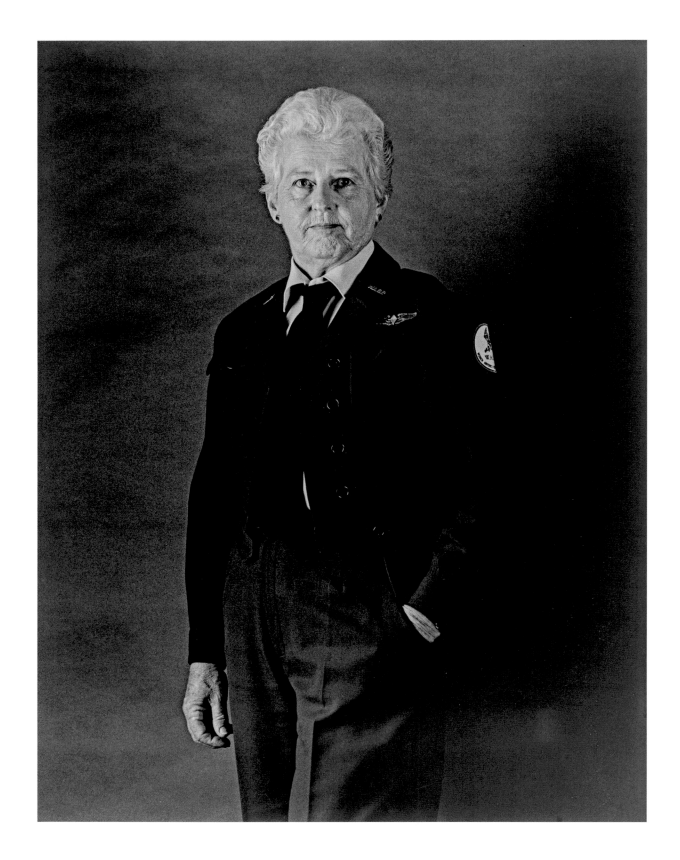

JOYCE SHERWOOD SECCIANI, 1986

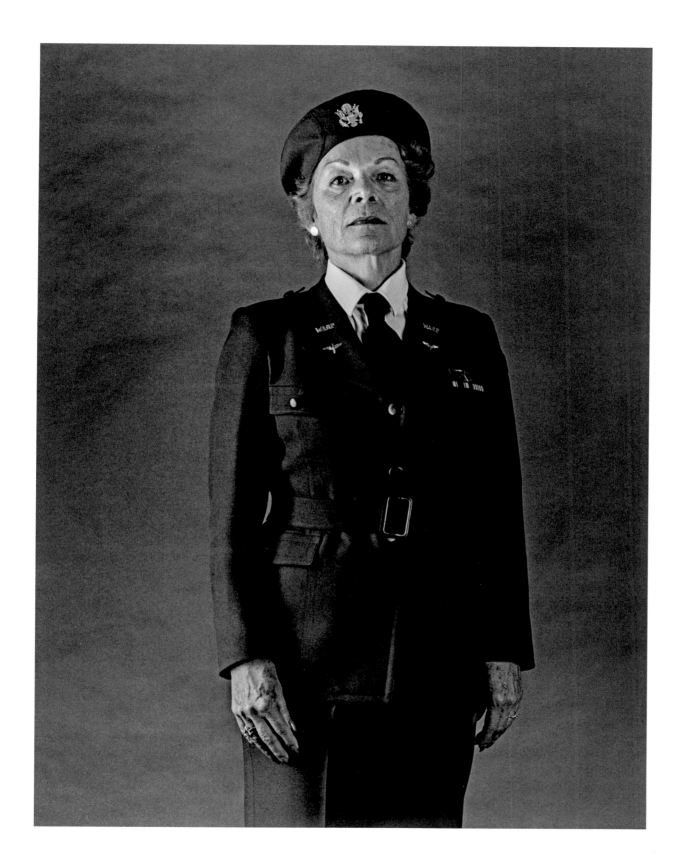

BONNIE DOSEY SHINSKI, 1986

75

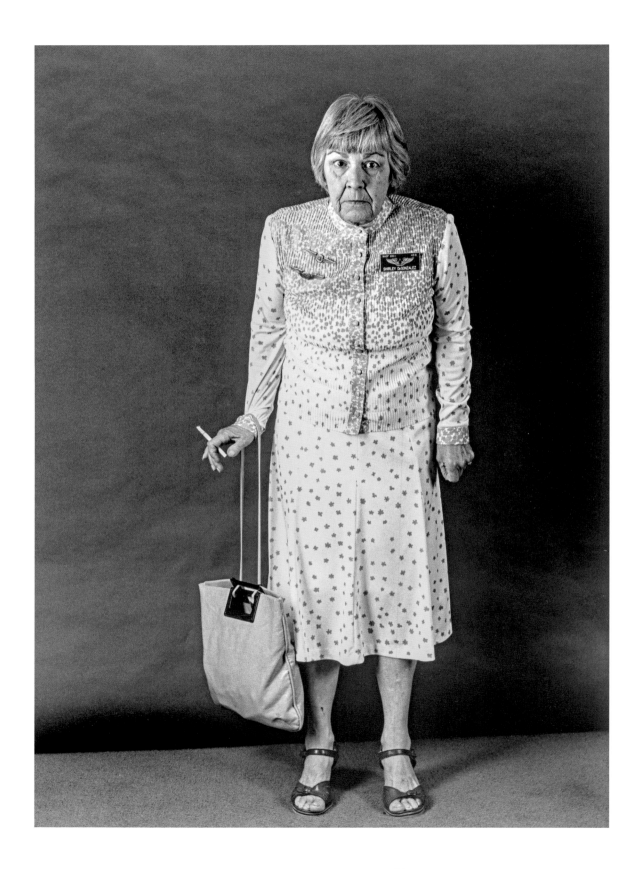

SHIRLEY CONDIT DE GONZALES, 1986

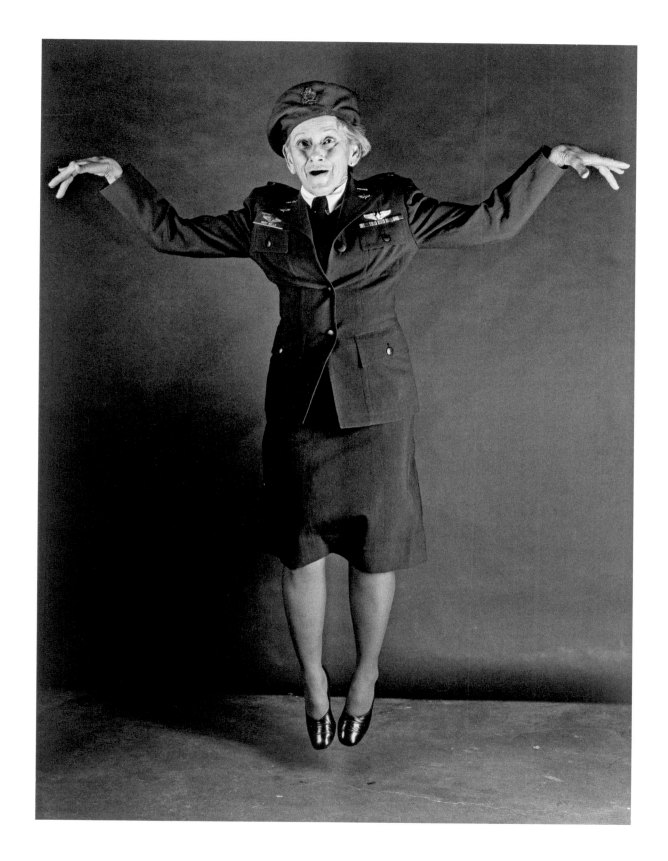

MARY RETRACK WELLS, 1986

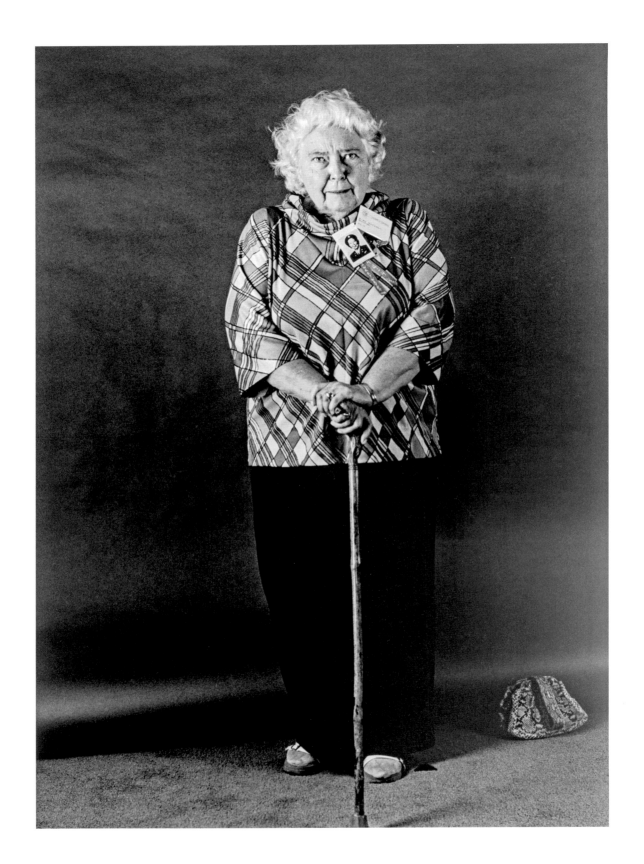

GREY ALLISON HOYT DUNLAP, 1986

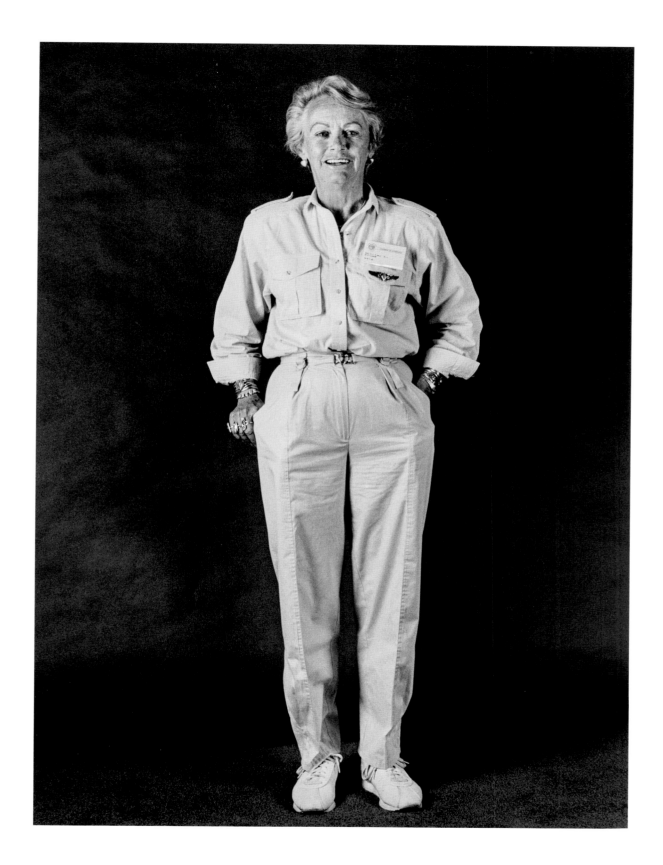

SHIRLEY CHASE KRUSE, 1986

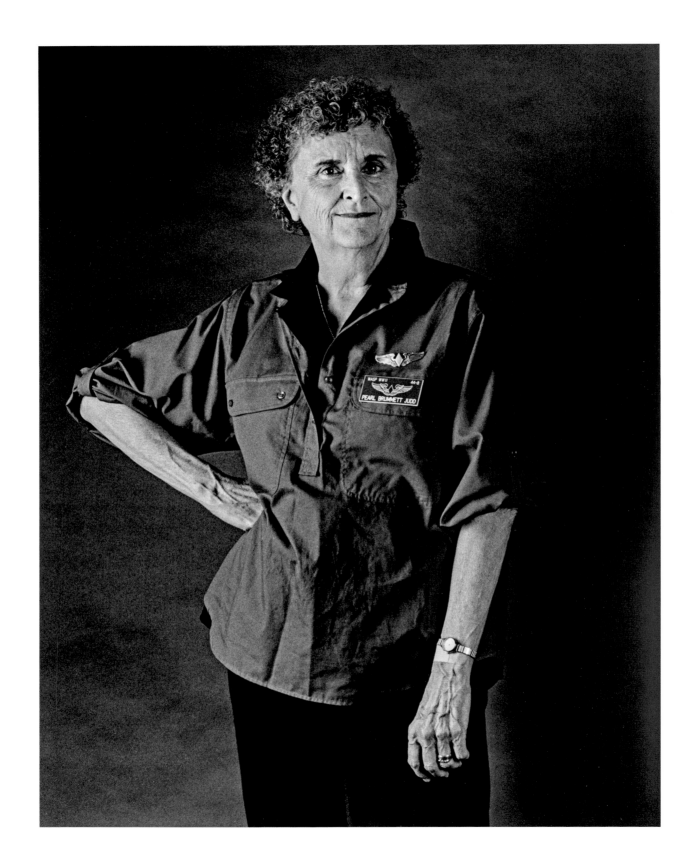

PEARL BRUMMETT JUDD, 1986

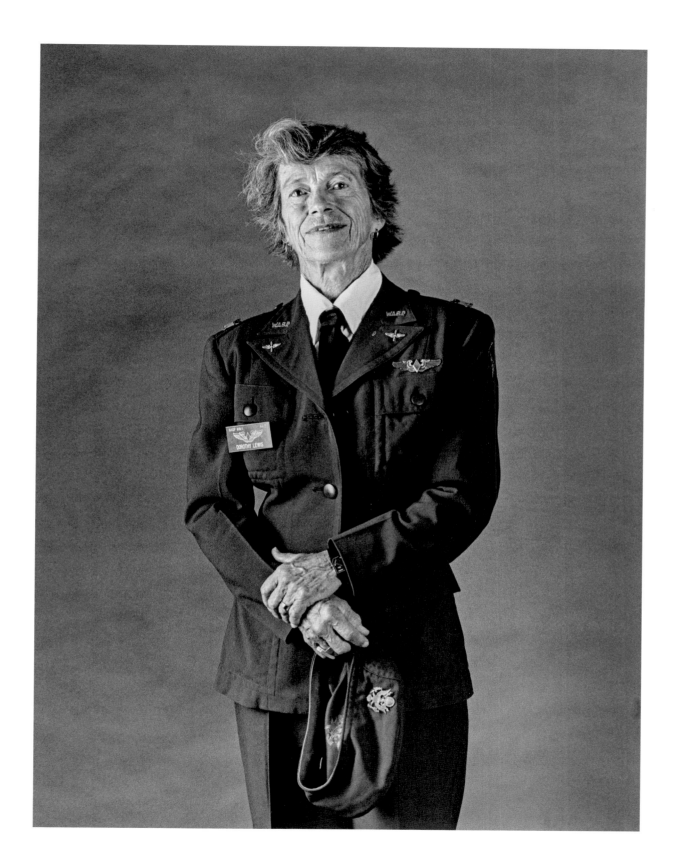

DOROTHY SWAIN LEWIS, 1986

Soviet Airwomen
in World War II

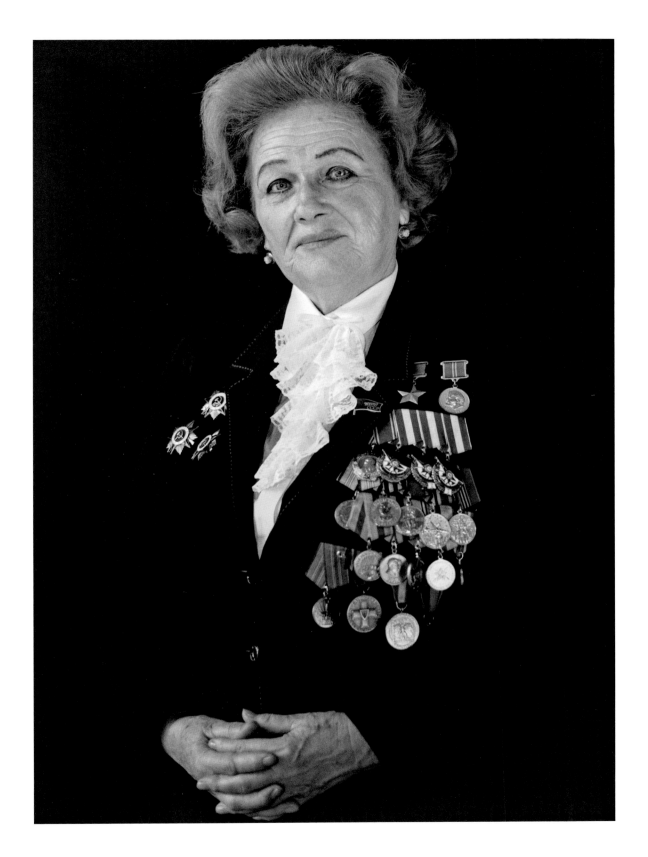

NADEZHDA POPOVA, 1990

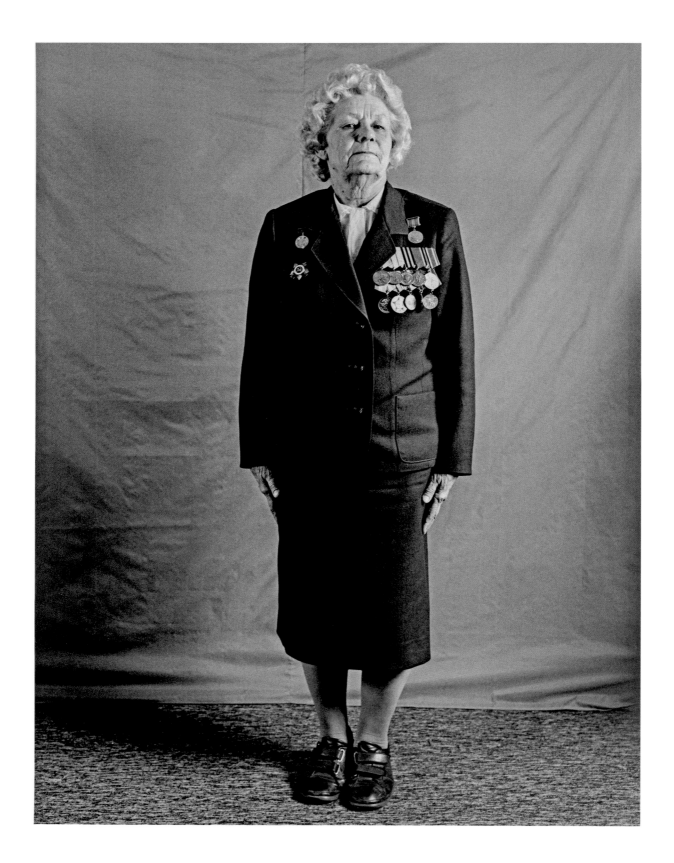

INNA PASPORTNIKOA, 1990

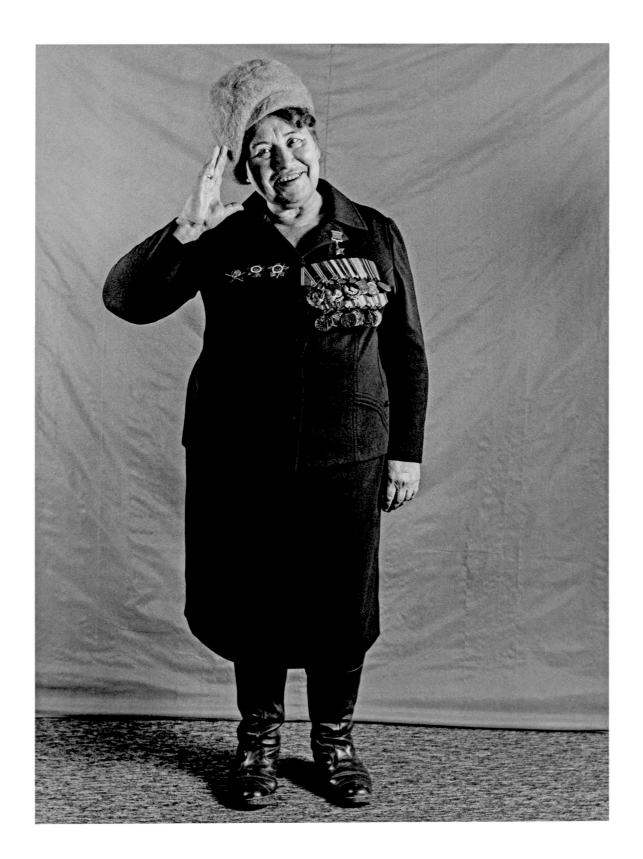

LARISA LITVINOVA-ROZANOVA, 1990

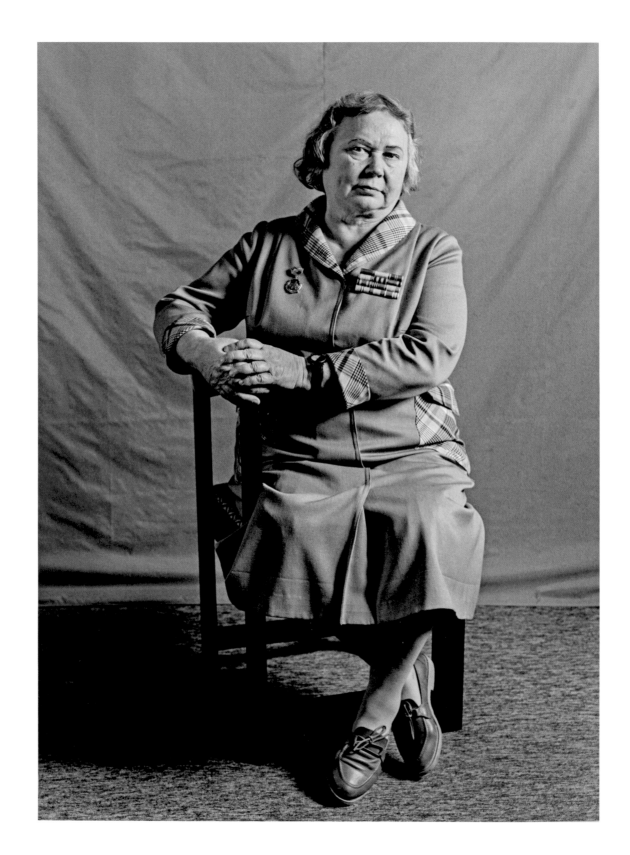

NATALIYA ALFYOROVA, 1990

88

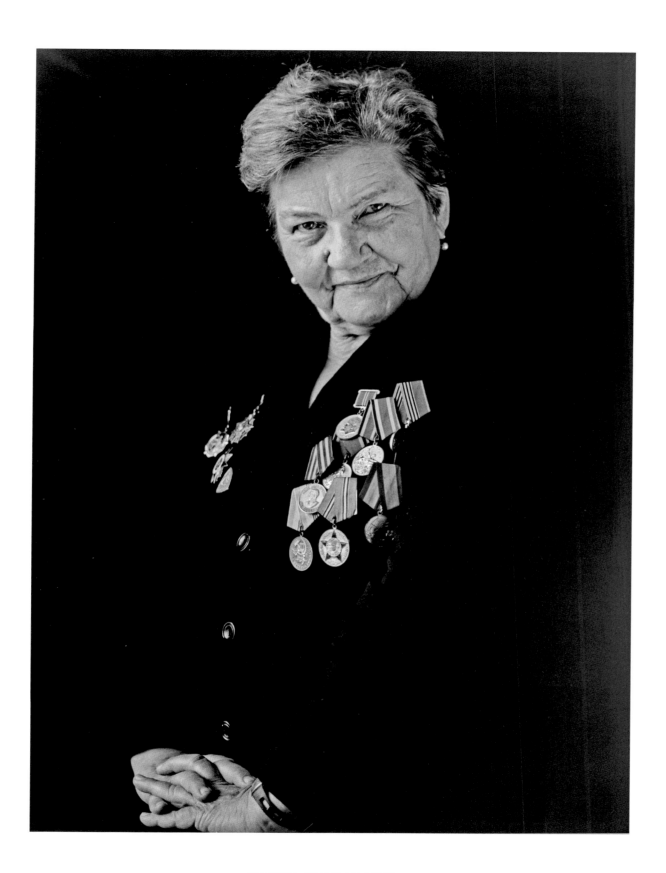

VALENTINA VOLKOVA-TIKHONOVA, 1990

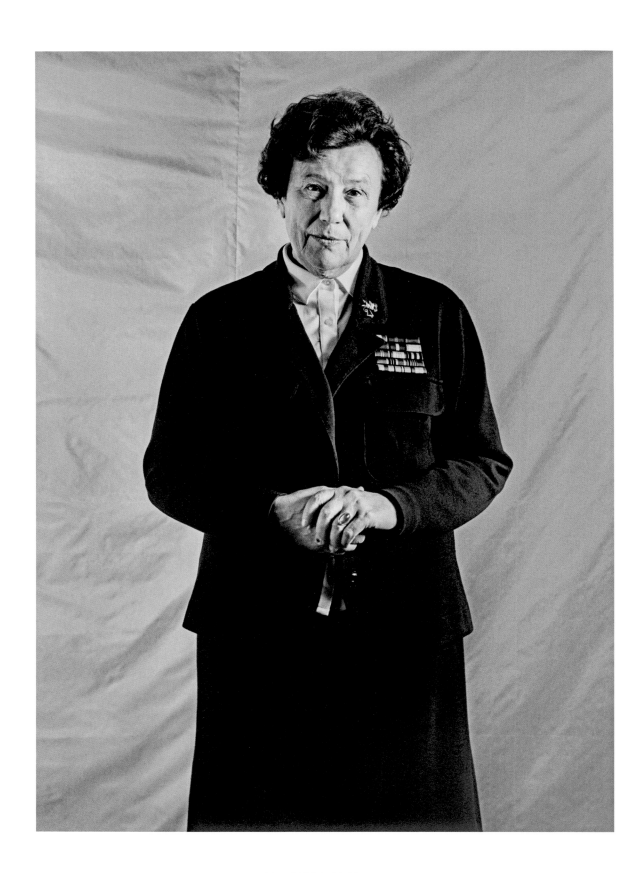

IRMA RAKOBOLSKAYA, 1990

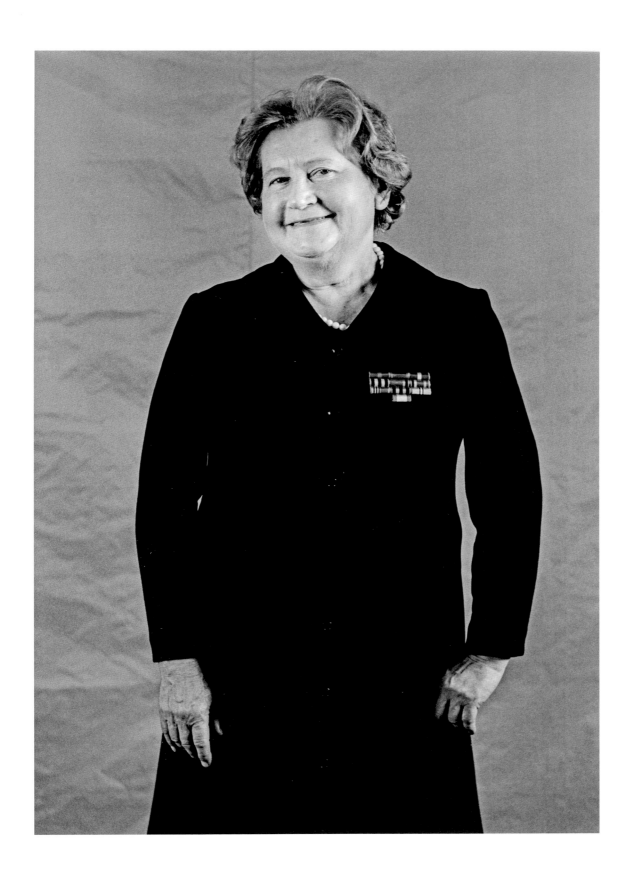

ANTONINA PUGACHOVA-MAKAROVA, 1990

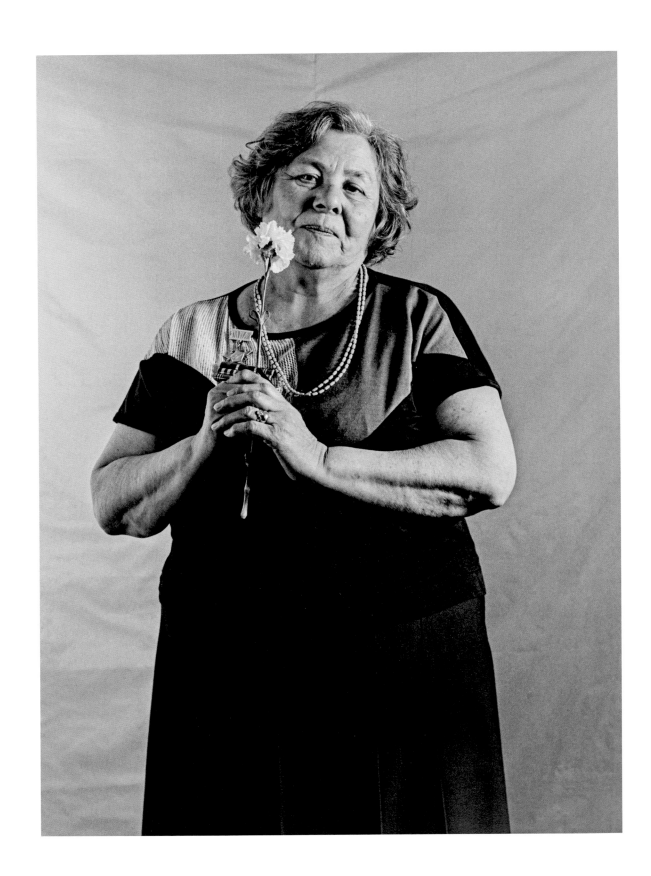

YEVGENIA GURULYERA-SMIRNOVA, 1990

92

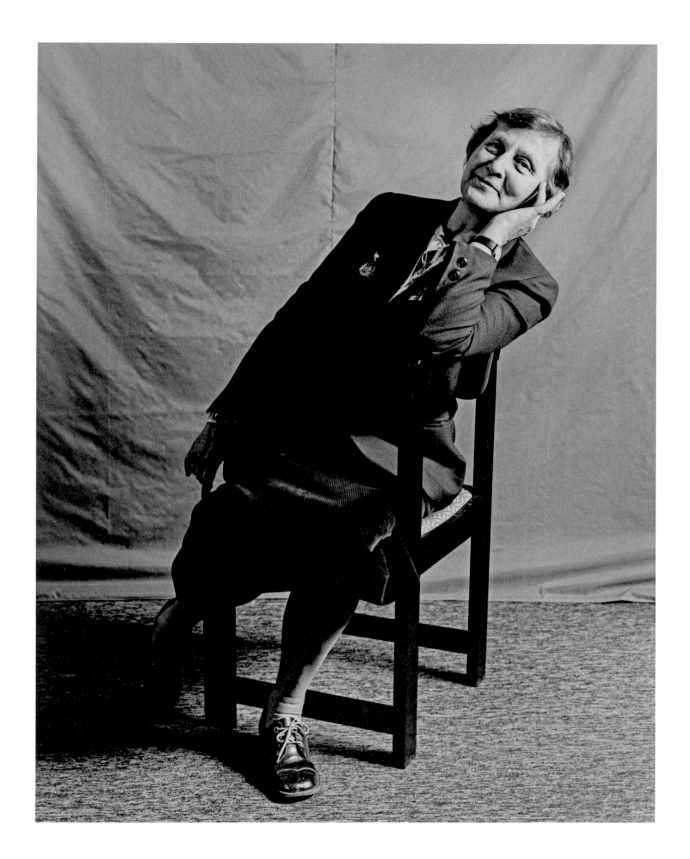

NATILILYA SMIROVA,1990

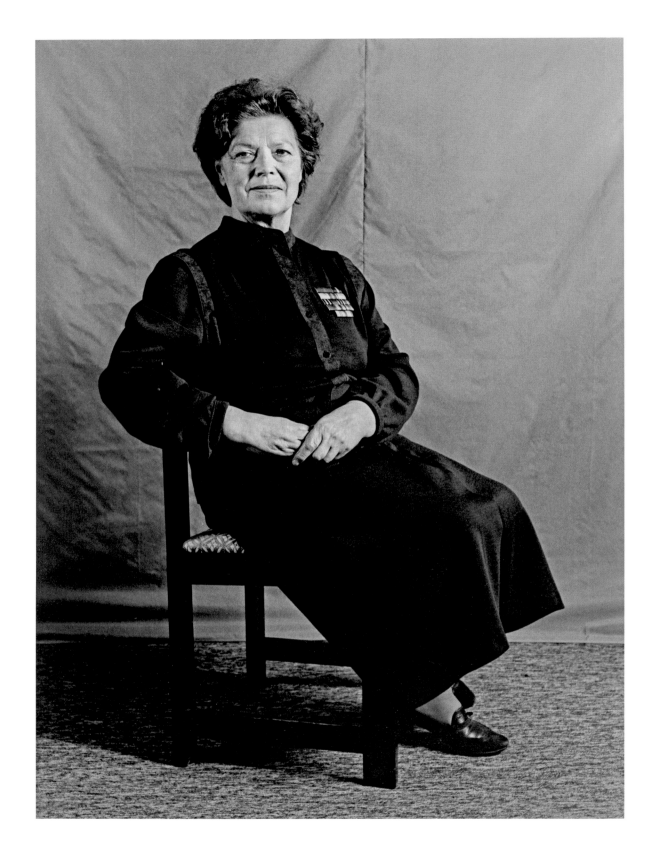

NINA KARASYOVA-BUZINA, 1990

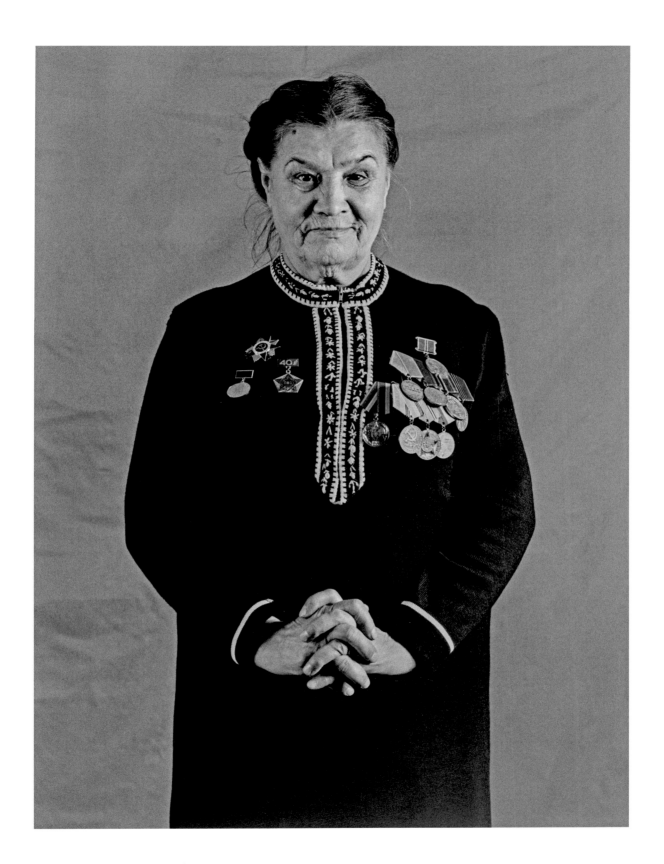

NINA YERMAKOVA, 1990

The Crop Duster

Close by the field
In from the sweet dawn
the acrid belch of white curlicues
hugging the field
a deadly beauty
in passage

The pilot
pale face
contrasting
a smile's radiant red lips
Seductive
What a smile does
for a face
sunrise
before the sun.
Such grace
a delicate touch this
wicked red slash
would eat
the heart out
with salacious kisses

Picture this airborne
apparition
this act
Of becoming a vision

Anne Noggle, ca. 1984–1988

PORTFOLIO V

Self-Portraits

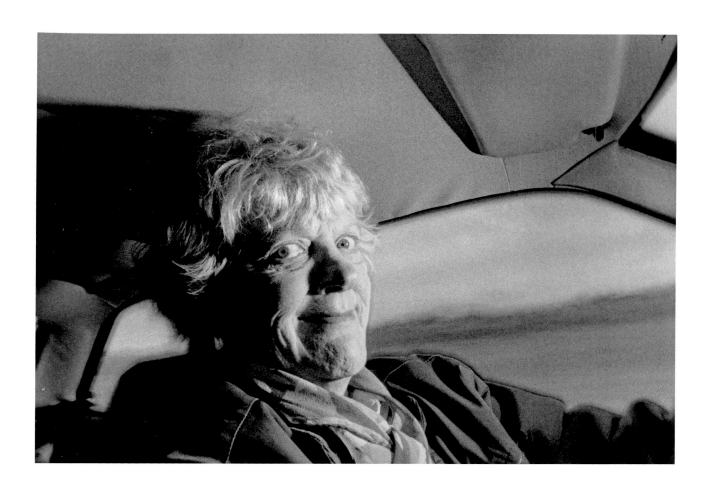

MYSELF AS A GUGGENHEIM FELLOW, 1982

101

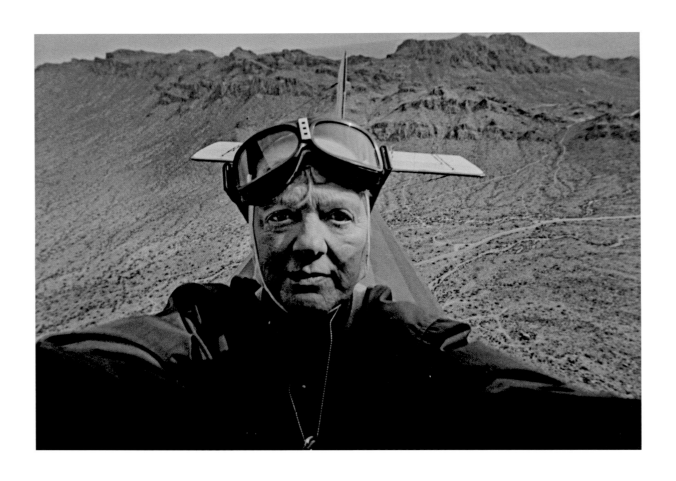

MYSELF AS A PILOT, 1982

102

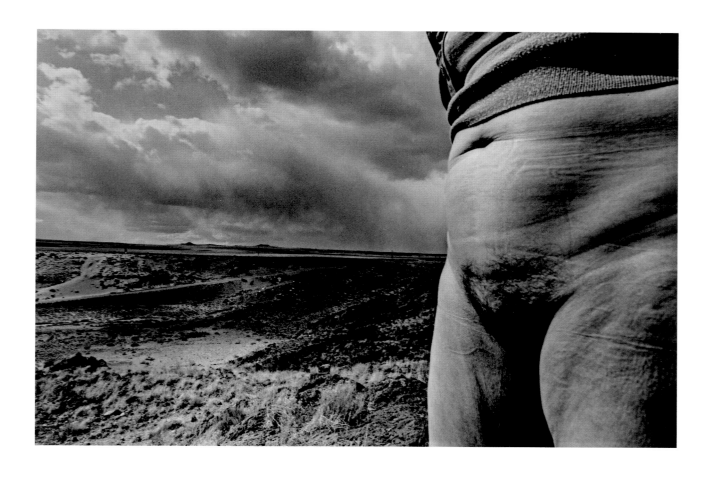

STONEHENGE DECODED, 1977

103

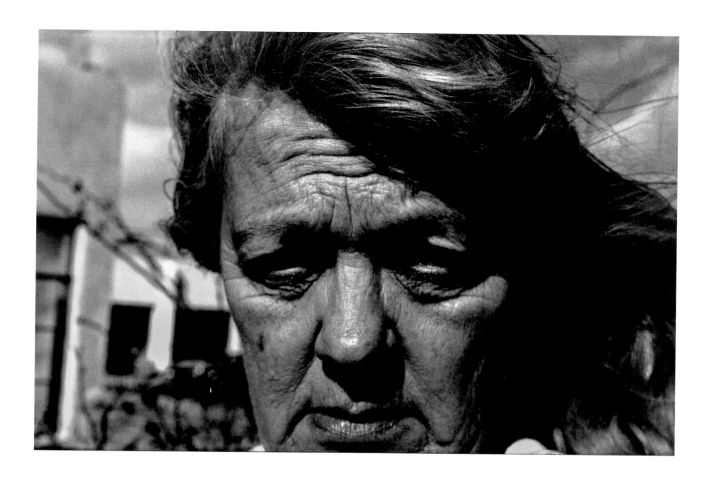

SELF-PORTRAIT, BEFORE SURGERY, 1975

105

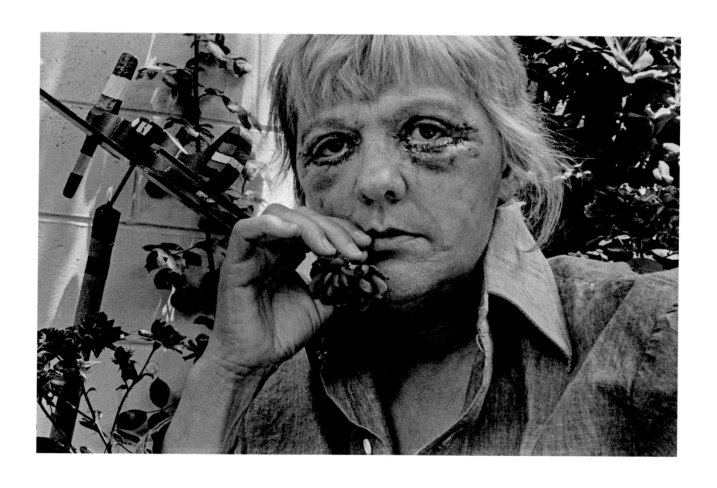

FACELIFT NO. 3, 1975

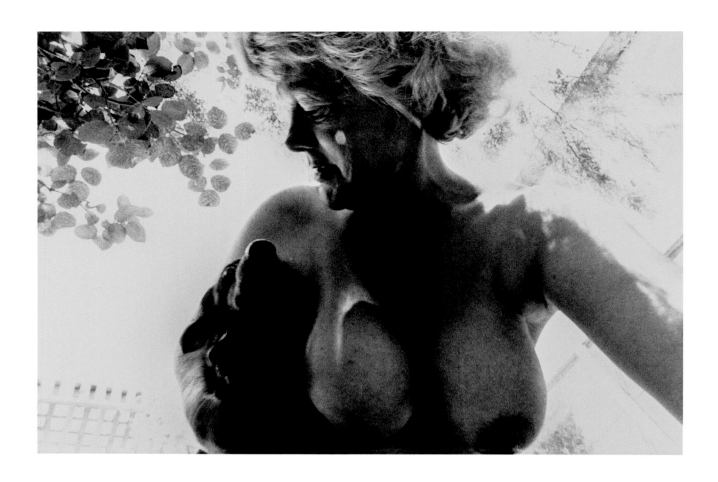

SELF-PORTRAIT WITH PEPE, 1970

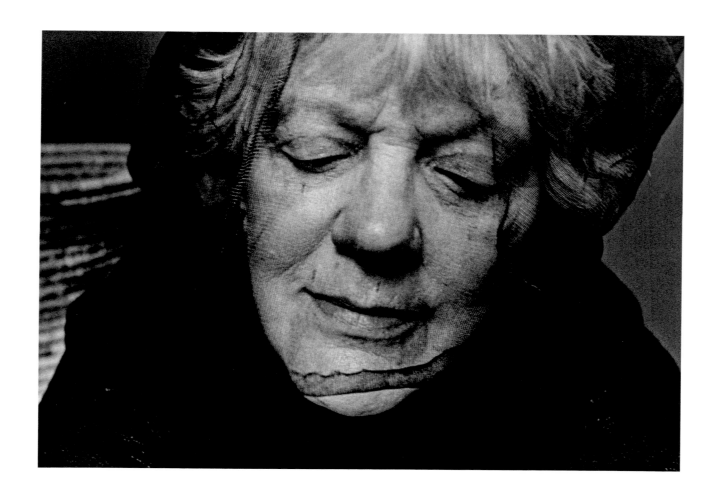

THE LATE GREAT ME, 1983

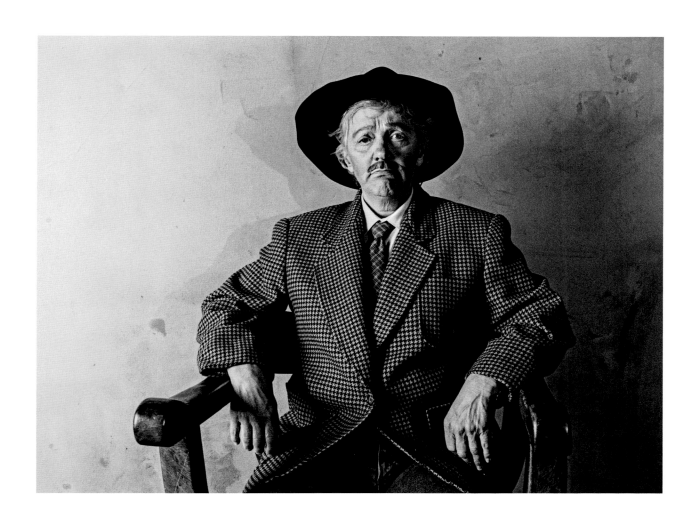

IT IS I, IT IS HE, IT IS SHE; HOMAGE TO VDC (Van Deren Coke), 1986

111

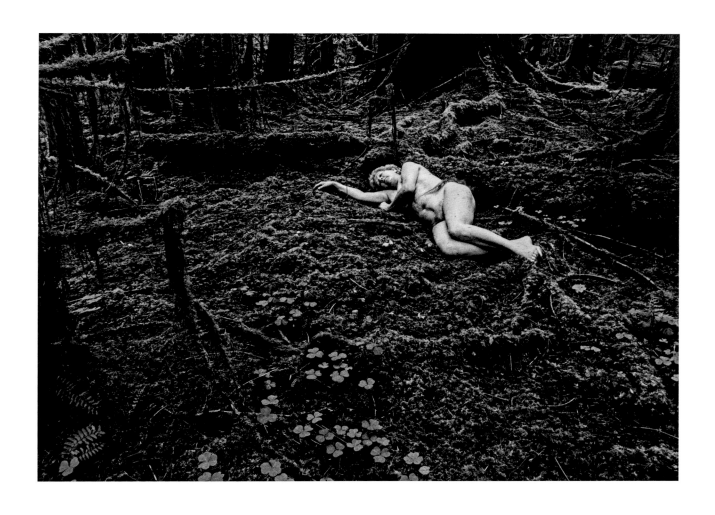

THE OLD NYMPH, 1985

113

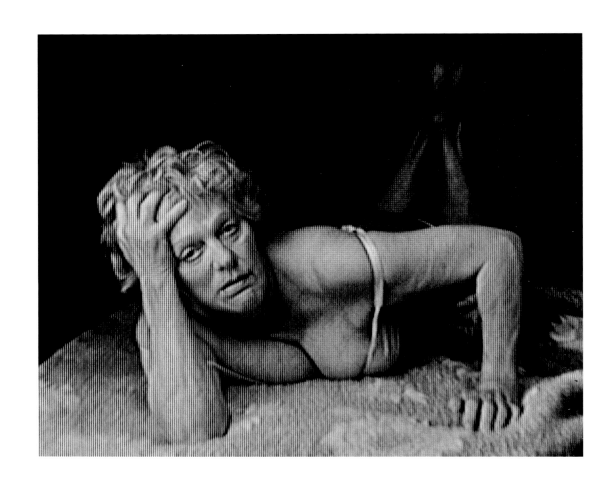

MADAME X, 1987

114

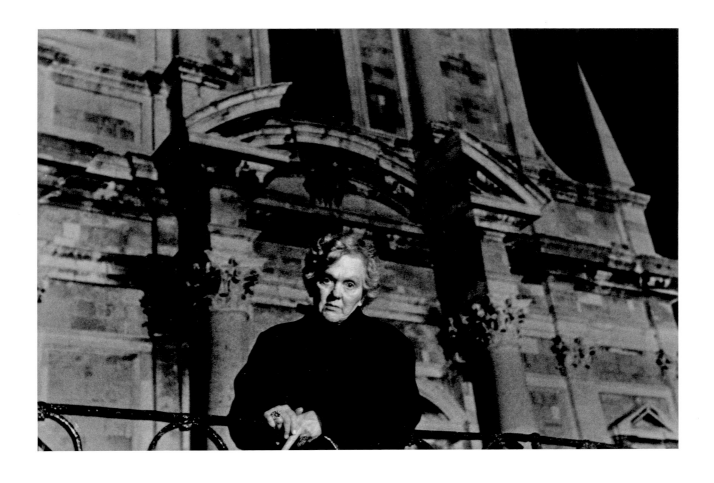

END OF THE PARTY, 1989

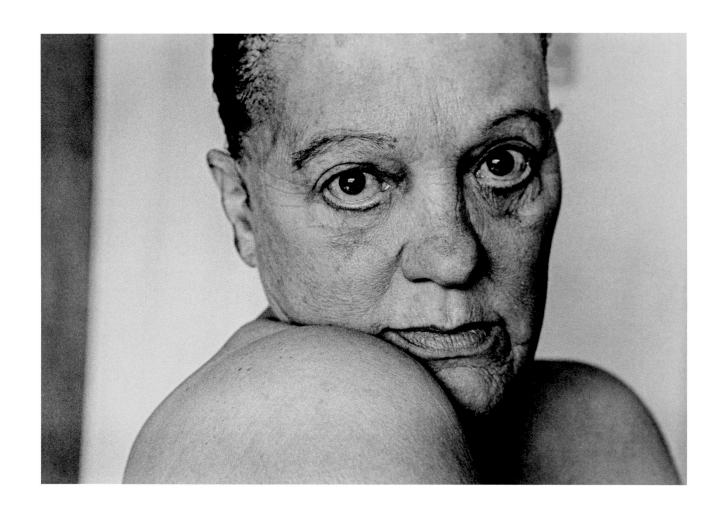

A ROSE IS A ROSE IS A ROSE (Gertrude Stein), 1985

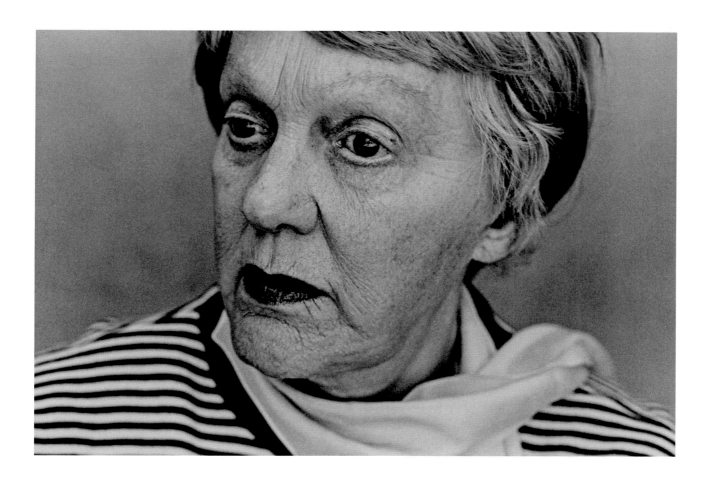

ADDENDUM TO VIRGINIA WOOLF, 1990

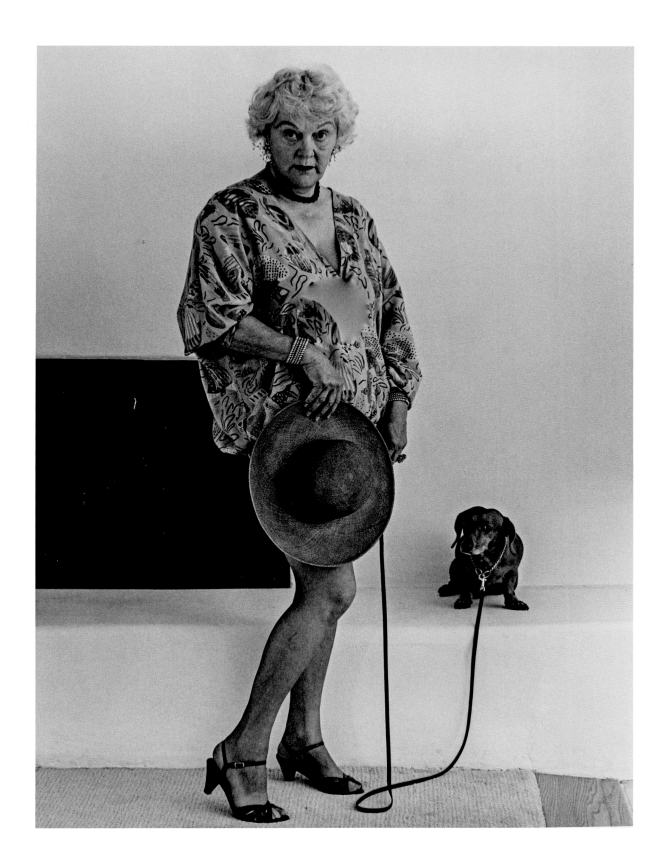

THOROUGHLY MODERN ME, 1989

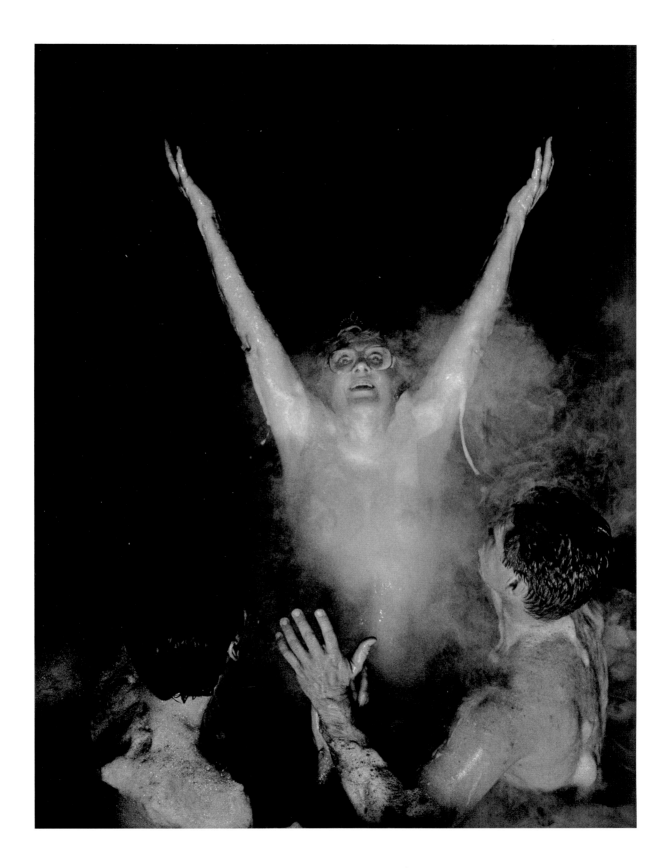

STELLAR BY STARLIGHT NO. I, 1985

121

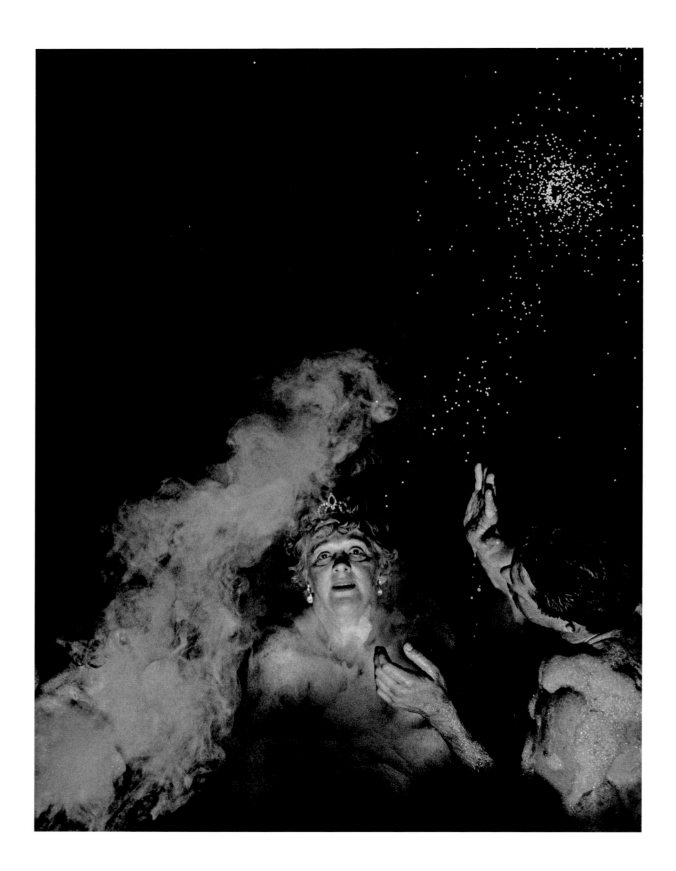

STELLAR BY STARLIGHT NO. 2, 1985

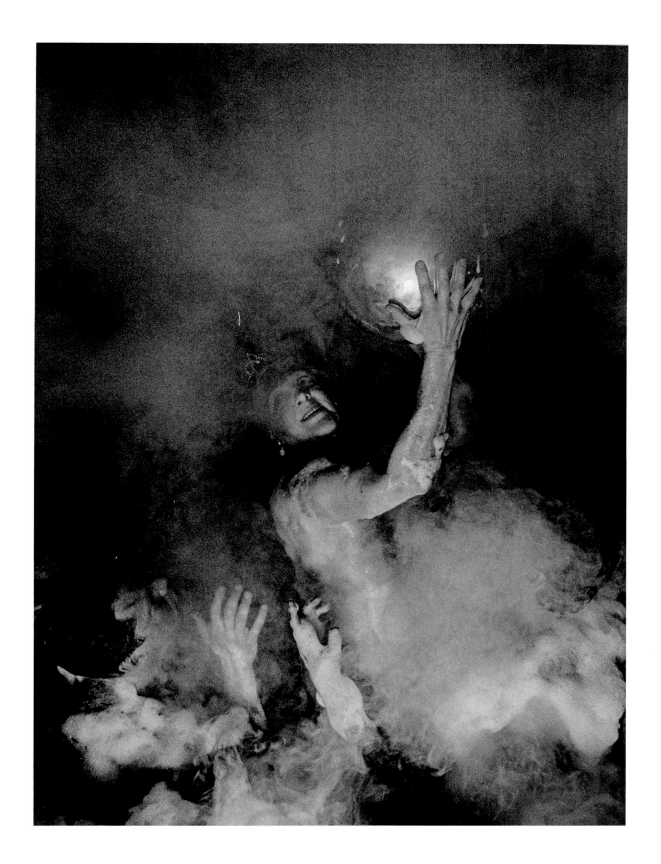

STELLAR BY STARLIGHT NO. 3, 1985

The Soft Whisper

Eventually life erases us from the scheme of things,
our plans, as we call them, for someday.
Once our hopes have fled, free in that vast ocean of our past
Only a life lived proves the presence to be real,
and the soft whisper of old wings.
Our own individual future overtakes us
While God's domain, the kindergarten of other worlds
teases us with an undocumented forever,
and a peace we've never known, or really wanted.
So get up from your knees, it is too late to prove
Your worth
Your piety
You are as you lived.

Anne Noggle, 2001

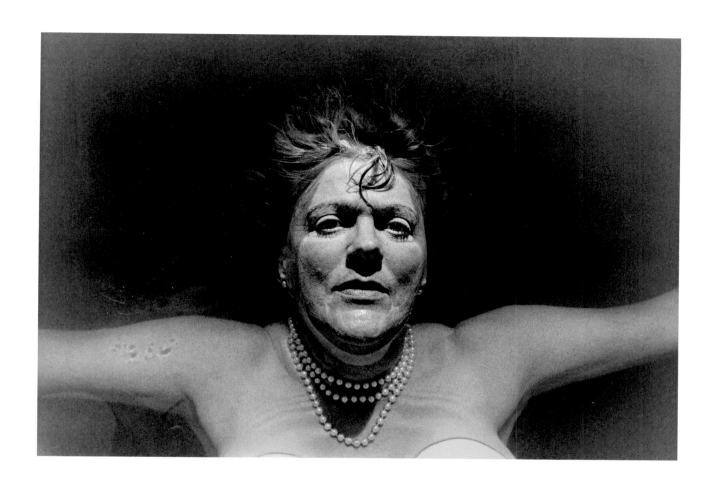

SELF-PORTRAIT IN COCHITI LAKE, 1978

127

"The Thrill of It All":
A Portrait of Anne Noggle

Lili Corbus

Bᴀᴄᴋ ɪɴ ᴛʜᴇ ᴍɪᴅ-1990s, when Martha Strawn and I were teaching at the same university, our conversations often veered to photography, the focus of our professional lives. We lamented what we perceived as a lack of attention to Anne Noggle, a photographer we both admired. Now over twenty years later, I am honored to participate in this publication of Noggle's work. That I turned sixty on my last birthday brings me a far deeper, personal level of understanding of her work.

Portraiture, Noggle's primary interest, has dominated photography since the invention of the daguerreotype in 1839. Photographs quickly replaced small painted "miniatures" while inheriting their established conventions and poses. Their popularity reflected an ever-growing zeal for more affordable likenesses of visual identity. From daguerreotypes, calotypes, ambrotypes, cartes de visite, and tintypes to the rise of Kodak snapshots and selfies today, a range of photographic means has been used to capture those eager to preserve, celebrate, or herald people's existence.

Every portrait exists on multiple planes of intention: as a physical likeness, a reflection of character and values, an indication of power and status, and much more. Serious portraitists seek to produce images that delve beyond outward appearance to convey a sitter's complexity or inner spirit. But each portrait is fraught with layers of meaning and ambiguous tensions. Who or what is being captured? What does the picture tell us about the subject, the photographer, its times? As Graham Clarke has noted, the portrait photograph is "the site of a complex series of interactions—aesthetic, cultural, ideological, sociological, and psychological"; it exists in "a constant dialectic of signification."[1]

Noggle was primarily a portraitist of herself as well as others. She focused on older female subjects and what she called "the saga of fallen flesh." Born on June 12, 1922 in Evanston, Illinois, Noggle grew up in a rooming house during the Depression years with her mother, Agnes, and sister, Mary; early on her father left the family. At age seventeen, inspired by the sight of Amelia Earhart flying in an air show, she approached her mother about learning to fly. Agnes gave her blessing (in writing), prompting Anne's grandmother to respond, "You just signed her death certificate!"[2]

Thus began a period in Noggle's life devoted to her first love, flying. A trailblazer, at age twenty-one she volunteered to become a Women Airforce Service Pilot (WASP) during World War II. After the WASPs were disbanded in 1944, she became a stunt pilot, flying instructor, and crop duster. In her early thirties she enlisted in the Air Force, a job that took her to Paris, where she discovered art. At age thirty-seven, in 1952, she retired on disability (she had developed emphysema from her work as a crop duster), having flown airplanes for a living for more than a decade and logged over 6,000 hours in flight.[3]

Noggle moved to New Mexico and with GI Bill in hand enrolled at the University of New Mexico. By 1960 she was almost forty and working on a bachelor's degree in art history (1966). But after taking photography as a studio art requirement, she found a new passion and "fell in love with another machine, the camera."[4] She went on to receive an MA in photography in 1969. Her first solo show followed in 1970 when she was forty-eight, the same year she started teaching at UNM, and she was hired as the first curator of photography at the Fine Arts Museum of New Mexico in Santa Fe, a position she held until 1975. She earned three National Endowment for the Arts fellowships (1975, 1978, and 1988) and one Guggenheim Fellowship (1982). She retired from UNM in 1984. Despite her late start in photography, she had more than sixty-five one-person exhibitions. Her work was shown internationally in more than 250 exhibitions. She died at age eighty-three, in 2005.[5]

During her earliest years in photography, Noggle's roaming eye captured architecture, nature, street scenes, children, nudes, panoramas, even allegorical setups. Throughout her career she favored 35 mm cameras and wide-angle lenses and produced mainly silver gelatin prints.

Her primary influences included Diane Arbus, whose penchant for the bizarre and off-kilter creeps into Noggle's work. Arbus's attraction to societally perceived oddities, misfits, and outcasts, Noggle said, "freed all of us to do as we pleased with our subjects." Early in her career she won an art show (and $100) that was juried by Arbus ("She'd liked them," Noggle later boasted).[6] Portraits that chart Arbus waters include Noggle's rarely seen series *God Save the Queens*, documenting cross-dressers and transsexuals (circa 1975).[7] Other influences Noggle recognized were Henri Cartier-Bresson, August Sander, Disfarmer, Judy Dater, and the Victorian portraitist Julia Margaret Cameron, her "kindred spirit." Cameron (1815–79) also came to photography later in life, at age forty-nine, after receiving a camera from her daughter.[8]

FAMILY AND FRIENDS

Noggle typically worked from a place of intimacy, concentrating on subjects she knew or felt attracted to, often her closest friends and family. She would dedicate *Silver Lining*, a book of her photographs published in 1983, to them, "To Yolanda, Mary, Shelley, and to the memory of my mother Agnes."[9]

The diverse photographs of her sister, Mary, and mother, Agnes, demonstrate Noggle's commitment to portraiture and the complicated nature of representation. There is a consistent sense of affection, playfulness, honesty, respect, and rapport as her willing subjects pose. There is little idealization, nor a sense of exploitation. (See portfolio I.)

Noggle began to make her touching, often unflinching images of her mother around 1970 and continued until Agnes's death ten years later. She depicts Agnes as a vibrant, layered being, aging and evolving. She is confident, spirited, sociable, distorted in shower glass, regal in a fur collar mimicking her feathery white hair, beside her bed and in a wheelchair, fragile in her dressing gown. One of her most reproduced images is *Artifact* (1976), wherein all that viewers see are her mother's textured hands holding out a set of false teeth boldly highlighted against the black background. (See p. 42.)

Like Roland Barthes writing about his mother and photography in *Camera Lucida* (1981), Noggle is "straining toward the essence" of her mother, looking for her truth, beyond the icon of "Mother." To Barthes, a sense of death hovers over any photograph; it has "a certain but fugitive testimony" to life, a "that-has-been" quality of what once was but is no more. His ruminations resonate in the images of Agnes as we witness her journey.[10]

Viewers bring similar personal associations to images of Agnes, often projecting a pall of death onto them. In her essay on Noggle's work, Jan Zita Grover called them "harrowing" portraits as the mother "devolves into the image of a dried stick of a figure" heading toward "imminent" death. Estelle Jussim noted that Noggle "relentlessly recorded her mother's gnarled and furrowed hands . . . but managed to endow her mother's last portraits with sublime dignity."[11] (See pgs. 41 and 43.)

One of Noggle's most significant relationships was with another older woman, the exotic and lively Yolanda Shaw Belloli, an artist Noggle met soon after moving to Albuquerque, in 1949. According to Lynn Davis, "these two independent, adventurous and intelligent women clicked."[12] Yolanda became a mentor and "fairy godmother" to Noggle, who became her "surrogate daughter." They were "inseparable" until Yolanda's death at age eighty-nine in 1983, when she left Noggle her unique Santa Fe estate and with it a new degree of financial security.[13]

Yolanda as muse, with her idiosyncratic force of personality, mystery, insouciance, style, and attitude, evoked some of Noggle's most memorable portraits, full of ambiguity, tension, and even transgressive qualities given their "defiant exposure of what older women are conventionally expected to hide."[14] We see her in turbans and sunglasses amidst the art and clutter of her Spanish-style home, outside gardening as if in a frenzy, or gazing candidly at us, cigarette in hand, fur cap on head. (See pgs. 66–67.) She is always recognizable and utterly herself.

Marjorie "Shelley" Shellenberger was a war veteran like Noggle. They met when they were stationed at Kirtland Air Force Base in the early 1950s. "Shelley adored Anne," Davis recalls.[15] Shelley's portraits include a bathroom scene with Agnes, both sporting

silly plastic shower caps, and looking wistful against a vast black sky, the moon a tiny prick of light in the darkness. In *Shelley* (1978, subtitled *Hot Flash Series*), her face frowns, its furrowed lines accented by harsh strobe light as a menacing dark blur of man looms behind her. (See p. 48.)

Noggle loved and admired these women; she was sensitive to their place in the world. She professed to like their "older faces, not because of aging itself, but rather the look of the face, the revelation of life, and the conflict between what was and what they are now."[16]

Other sitters included friends and colleagues, such as the venerable photographer Laura Gilpin ("an important touchstone" for Noggle), University of New Mexico colleagues Van Deren Coke, Thomas Barrow, and Betty Hahn, and photo historian Estelle Jussim.[17] (See p. 54.) The photographer Judith Golden made an appearance in Noggle's rarely seen Cibachrome color series, *Earthbound* (1979), as a pair of pointy green cowboy boots with a bold red fighter plane slicing between her legs.

Noggle also sought new subjects during trips to England (circa 1979), Seattle (1982), and Texas (1983). These series highlighted not only older women but also couples, male sitters, and family groups. "I got tired of trying to do stripped-down portraits where I was drawing out someone's essence—I wanted to photograph the surface." Grover added, "She worked to quell an urge to impose her own will on her subjects" and to accept them as they were.[18] (See p. 60.)

SELF-PORTRAITS

Hello, here is the physical self, the only belonging which I have exclusive rights to possess, enjoy and dispose of. I have reigned supreme inside it, shoveling in hot chili, keeping it up till all hours, making it sit still while I think, and using it to portray the way I feel. It has been my support system for sixty-three years. Only lately have I begun to feel like it looks. Sic transit gloria sepse![19]

Noggle is perhaps best known for her penetrating and often surprising self-portraits. She increasingly turned to herself for expressions of ideas she could not "extract from anyone else." As Elsa Dorfman observed, she "camps, vamps, plays, at the same time revealing and withholding. . . . They are celebratory bits of theater."[20]

The variety of shots captivates: Noggle clutching her dachshund Pepe amidst pendulous breasts, her bare feet standing on the wings of an airplane, her face filled with gleeful delight at receiving a Guggenheim, and floating in Cochiti Lake in a string of pearls like Ophelia in a 1950s *I Love Lucy* episode. We see her as reclining teenager, pilot, and writer (twice, as Gertrude Stein and Virginia Woolf), a sultry *Madame X*, and even posthumously in *The Late Great Me*, her eyes closed and face veiled like a widow or Renaissance marble statue. (See portfolio V.)

Photographic homages include her cross-dressing as Van Deren Coke, Noggle's much admired professor who built the distinguished art program at UNM, in *It is I, It*

is He, It is She (1986). In 1985 she re-enacted West Coast photographer Wayne Bullock's *Child in Forest* (1951) with a cheeky self-portrait of her naked body lying in a rain forest, Noggle's sixty-three-or-so-year-old female form replacing the enigmatic child in Bullock's original. That child has now grown into an "Old Nymph," still prone on the forest floor.[21] (See pgs. 111 and 113.)

Many of Noggle's photos bring humor and wit to serious reflections on aging and gender. She noted of her own work, "They're playful, but there's meaning to it too, and sometimes taking oneself very seriously is not the best way to get across what you want to say. I think that a little humor in with it, even though it's bittersweet, says more than it does when you take yourself very seriously, because you can get over the sentiment and other things."[22] In an interview, Anne Tucker observed, "The pictures of yourself frequently make me laugh." Noggle replied, "They're supposed to."[23]

Noggle's fantastical *Stellar by Starlight Series* (1986) consists of three staged photos based upon her notion of an archetype, an older woman who was "mysterious, joyful, powerful . . . adored by mankind."[24] In the series Noggle becomes that archetype; she is queenly, clothed only in baubles, glasses, and a tiara that shines against her white hair. Surrounded by the foam and steam of a Jacuzzi spa, this new Venus is surrounded by two attentive and muscular male Adonises. In one she picks up a "planet" and holds it aloft with ease, like some powerful female Titan. With its wink to ancient mythology, the series pokes fun both at herself as subject and as society's perceptions of "acceptable" behaviors for aging women. It was all theater; the males were volunteer students and a fogger was rented to create the hazy otherworldly setting. The scenes are full of "fantasy and play, sensual delight and sexual possibility."[25] (See pgs. 121–123.)

The series brought sexual energy and agency to an older woman's body. Feminist writer Joanna Frueh commented on the *Stellar* series in 1994, linking it to sexist societal norms for older women and sexuality: "Female aging remains in American society what Susan Sontag called it in 1972, 'a process of becoming obscene.' . . . That old women are repulsive is one of the most profound esthetic and erotic feelings in our culture." Frueh appreciated Noggle's "radical" voice bringing "erotic social security to old(er) women." "A wonderfully manic delight animates Noggle's face, her breasts are luscious, and as artist she creates an atmosphere reminiscent of the lighthearted seductiveness and seduction in Rococo paintings."[26]

FACELIFT

Noggle's best-known self-portraits are from her *Facelift Series* of 1975.[27] We see "before" and "after" the procedure in these ironic images that make something usually deemed private a very public affair. Paradoxically, Noggle documented aging with a sense of acceptance yet attempted, openly, to escape reality via plastic surgery. Such work acknowledges uncomfortable contradictions between ideals of youthful beauty, aging, vanity, and physical insecurity. Five years later she and Mary faced the camera in *Reminiscence: Portrait*

with My Sister (1980), wherein both pull back their skin to create "younger" faces, a gesture many women, given contemporary standards of beauty, can understand. (See p. 29.)

"For someone who's so interested in aging," Noggle said, "it's hard for me to explain about my facelift. . . . I've always been fascinated by something about my face, and it's interesting to see the changes and reverse them but at the same time see that they're taking place anyway." Furthermore, "If I am shown in my face-lift as attempting to stave off the visible aging process, it is also an indication of what an exercise in futility that is." When interviewer Anne Tucker said, "Those are tough pictures. I've watched people turn away from them," Noggle replied, "Well, they probably turn away from life too, and from their own mirrors."[28]

In what is probably the most reproduced image of the series (No. 3), we see Noggle's face stitched, bruised, moist, healing. (See p. 107.) Having endured grueling lung surgeries, this procedure was optional, and welcome.[29] She holds a flower to her mouth like a tango dancer; however, her mood is somber, and she stares back at us frankly. A toy plane, iconographic of her identity as pilot, sits in flowering vines beyond. It is both playful and deadly serious, acknowledging an elective surgery many hide from public view, to not appear vain or to protect the aura of aging "naturally" (which implies a concomitant sense of shame for looking "old"). Van Deren Coke appreciated this daring proclivity in Noggle's work, writing in the foreword to *Silver Lining* that she had "always been able to see through complacency and pretense." "Her anxieties," he wrote, "are those of all of us."[30]

AGING

Noggle's portraits challenge facile stereotypes of aging women as witches, cougars, sweet (or grouchy) grandmas, mean hags, wise crones, and more. Her poem "Sketch for a Self-Portrait" (p. 17) alludes to the tendency for old women to become what others see in them: "Have / we dissolved into the past, / are we granny or auntie, or that old lady down the street. . . . / Who look at my face and find me there?" Instead of caricatures, she sought to depict "the tension between the iron determinant of age and the individual character of the subject." In a speech to art students Noggle explained further: "I try for images that get beneath the surface into that unchanging arena of the human psyche, formed in early life, which grows into maturity but does not relinquish its basic character throughout one's life. That deepest self, discernible only to one who is patient, watchful, and perhaps older oneself. The image I see is of youth betrayed by age, of spirit strong but fragile with time."[31]

Noggle certainly recognized that all age groups meet challenges: "Sadness in youth is having nothing to live for, and the great sadness in age is nothing to die for." She also mused, "I know now that the zit at eighteen is as hard to deal with as the slightly sagging flesh at forty and the wrinkles at sixty."[32]

What constitutes an "old" woman is, of course, debatable. It typically signifies postmenopause and, in some imaginations, some degree of decrepitude, mental decline,

ill health, or unattractiveness. I remember the gasps from undergraduates when I'd show Alice Neel's nude self-portrait at age eighty, painting at her canvas, a frank depiction of her body still at work. Men are not immune; images of British photographer John Coplans, who documented his unidealized sixty-some-year-old male body in the 1980s, also caused some alarm. And now I'm old enough myself to receive "compliments" on my appearance such as "You look good for your age!" or to be asked, "How are you today, young lady?" Well-meaning language can serve to marginalize, or even denigrate, the aging as "other."

In short, the concept of "old age" brings baggage, eliciting anxieties and prejudices from viewers steeped in a culture that worships youth. In many reviews of Noggle's work, we read how her photos of aging women are "taboo," bearing implications of mortality and ugliness. A few find death, aging's constant companion, around every corner. Grover noted, "In Noggle's work, age is the impersonal catalyst of character, and she documents its encroachments sedulously, watches as it gradually displaces personality with death."[33] (See portfolio I.)

Some viewers find Noggle's older sitters discomforting, depressing, or even scary, like something in a horror movie. Reviews have called her images of old women "unsparing," "not easy to look at," or "difficult to look at" given "the inexorable process of aging." One writer saw Noggle's mother as "unable to escape her aged body, trapped in a nightmare."[34] "Many people see old age as a terrible time," Noggle wrote, "like a leaf drying up and blowing off a tree. . . . I don't see it that way at all. I want to show the human side, so that it overcomes any feelings about being ancient." Age brought, in her experience, newfound freedom and honesty, and "you become yourself." What changes, she wrote, "is the outer coating. Inside it's a matter of growth, not deterioration."[35]

The book *Women and Aging* (1986), a collection of essays and artworks, also attempted to offset negative perceptions facing older women. It featured portfolios by Noggle and Imogen Cunningham, whose book of photographic portraits of old women, *Over Ninety* (1979), was created while she, too, was in her nineties. Noggle's six photos in *Women and Aging* (of Yolanda, Agnes, Shelley, herself, and others) were accompanied by her own words. Below her facelift image she was quoted: "Old people already belong in the past . . . historical objects occupying space. I want to show who they are and how damned difficult it is as each of us in our time becomes one of them." Noggle also included her personal "credo," a statement about her fear of becoming a static relic: "I am filled with dread that I will wake up and find I have become a completely rational being with a finite set of values within whose framework I must mind my manners and dream my dreams."[36] (See portfolio II.)

Women and Aging also included Barbara McDonald's fiery speech on the subject of women over sixty, given at a women's studies conference in 1985. "Your 'sisterhood' does not include us," she proclaimed, and "we" endure "intolerable patronizing." Similarly, Baba Copper, a "66-year old Crone Futurist," pointed out that the ageism "old women

experience" is "firmly embedded in sexism." Among younger women, she added, an "aura of death and decay" permeates the concept of aging.[37]

Noggle's acerbic impudence counters negative images of old women as non-productive, asexual, unappreciated, unattractive, or easily ignored. Her portraits exist uneasily and ambiguously in realms that both acknowledge *and* defy aging's negative connotations. Her photos admit that we will age and our bodies will change. "People tell me that the photographs of me are not in any way flattering. They are not meant to be. They are supposed to be real. And how you look when you're older."[38]

FEMINISM

In *Stonehenge Decoded* (1977) Noggle stands like a monolith, an ancient Venus figure, naked from thigh to waist against the desert. We view a vast landscape where stone and flesh merge, the lines in her skin like Nazca geoglyphs in the earth, her pubic hair the texture of the scrub brush beyond. She is not passive but stands powerful in her surroundings, tapping into larger conversations of "nature/nurture," the "earth mother," and other issues significant to the women's movement of the 1970s. (See p. 103.)

Noggle matured artistically during a time when women were routinely excluded from textbooks and histories. This disregard provoked Linda Nochlin's vastly influential 1971 essay, "Why Have There Been No Great Women Artists?" Feminists protested and organized, founding the first women's art programs, *The Feminist Art Journal* (1972), groups such as Heresies (1976) and the Combahee River Collective (1977), and more. As Charlotte Streifer Rubenstein noted in 1982, "Women artists, stimulated by the new feminist consciousness, realized that their situation was appalling. . . . Yet 60% of students in art schools and 50% of practicing artists were women. . . . Women were being brainwashed without even being aware of it."[39]

Women artists responded in a multitude of ways: by reclaiming women's histories, celebrating "feminine" characteristics and sexuality, examining the roles of domesticity, racism, and ethnicity, reversing the objectifying male gaze, and more. And like many feminist artists of the time, Noggle drew from her "self." Joyce Tenneson Cohen noted, in 1978, "The women's movement, with its emphasis on finding and establishing a personal identity, has encouraged and legitimized this form of expression. Subjectivity and introspection, which in the past were inappropriately labeled as shallow, narcissistic, or 'feminine,' have suddenly become valued, even celebrated."[40] The artist could stand in as subject yet address far larger societal issues.

Feminist exhibitions and publications helped find lost histories. Anne Tucker's *The Woman's Eye* and Judy Dater's *The Feminine Eye in Photography* (images of women in control of their own representation) were both published in 1973. *The Dinner Party* debuted in 1974 and *Women Artists: 1550–1950* toured the US in 1977. *Recollections: Ten Women of Photography* opened in 1979 at the International Center of Photography.

Noggle, with Margery Mann, also contributed to the mounting evidence of women's artistic significance by organizing a travelling exhibit and catalogue: *Women of Photography: An Historical Survey* in 1975, showcasing fifty women photographers, starting with Cameron. Mann's essay brought many notable, neglected women to the history of photography, and Noggle's essay placed the show (uneasily) within the context of the women's movement. Even though her life and art might suggest the contrary, Noggle did not identify as a feminist. In fact, according to Christine H. Kirk-Kuwaye, she had "nothing positive" to say about the movement.[41] Noggle's position was not unusual among women of her generation, many of whom were ambivalent about feminist polemics. But "feminist" or not, Noggle helped rupture traditional images of women.

POSTMODERNISM

Noggle straddled two decades, photographing into the "postmodern" 1980s wherein French theory, deconstruction, and semiotics brought philosophical ruminations on indeterminate, ambivalent, and fluctuating conceptions of meaning. More and more photographers started to appropriate mass media, question "truth," and assume roles to create fictive "realities" that might uncover the social constructions of identity and gender. Performance was already an element in Noggle's work as she designed her self-presentations by means of dress, posture, and artifice. Tucker asked, "The photographs were staged, rather than found?" Noggle replied, "I thought them up, lying in bed at night."[42] She was not unlike Cindy Sherman (and others), fabricating scenes that undermined photography's supposed verisimilitude. Noggle experimented with these ideas in her *Recent Follies Series*, circa 1985, where we see grainy stills from video performances, of her alone (*Madame X*) and with Jim Holbrook, unclothed and in intimate poses. (See p. 114.)

But Noggle never transformed reality nor manipulated herself to the degree Sherman, who often becomes barely recognizable, did in her work. Dana Asbury noted, in discussing the exhibition *Self as Subject: Visual Diaries by 14 Photographers* (1983–84), "The photographer who uses the notion of autobiography in the most direct and unadorned way is Anne Noggle. Surprisingly, hers are the only straightforward self-portraits in this exhibit, hers the only literal interpretation of the self as subject."[43]

Not surprisingly, however, Noggle (ever distrustful of bandwagons and labels) was not keen on postmodern theory with its "conflicting and illogical wishlets wrapped in professional garb."[44] Kirk-Kuwaye discusses in depth Noggle's (anti-)relationship to theory, positioning her self-portrait *Thoroughly Modern Me* (1989) as a perfect reflection of Noggle's self-professed romantic, modernist tendencies. (See p. 119.) But Noggle's work is not easy to categorize; she challenges conventions ironically, she lampoons and parodies, she stages and opposes; in this sense, Kirk-Kuwaye places her (and I agree) as a "proto-postmodernist" since many of her images complement postmodern examinations of privilege, power, and identity. (See p. 3 and portfolio V.)

On the cover of *Silver Lining* is an iconic Noggle image, *Myself as a Pilot,* taken in 1982, when she was about sixty. Her goggles sit on her forehead like craggy mountains, and the aircraft's tail stretches out behind her. But it is a reverie of her past; she no long had a pilot's license by this time. She is actually sitting in the back of a glider, controlling her camera, not the plane.[45] (See p. 102.)

Noggle's last two large-scale series were enormous achievements that melded "the two greatest loves of her life," flying and photography.[46] She and other WASPs met regularly at reunions in Sweetwater, Texas, to remember their days flying missions to free male pilots for combat duty. It was dangerous work, transporting cargo, training pilots, and towing targets for air-to-air gunnery practice. They faced sexism, resentment, and discrimination as "powder-puff pilots" but eventually earned respect for their performance and sacrifice.[47]

In 1986 Noggle photographed the WASPs attending that year's reunion. (See portfolio III.) Noggle reminisced: "This sense of belonging is all the more intense when the duties involve danger and risk. That makes it so rare with women. Add to that the kind of independent women we are and you have a portrait of a Women Airforce Service Pilot. I think we are extraordinary and I decided that I would take, not a group portrait, but individual images. . . . We may not be young any longer but we are very much alive."[48]

For God, Country, and the Thrill of It: Women Airforce Service Pilots in World War II was published in 1990 and dedicated to the thirty-eight WASPs who died during their service. Noggle wrote in the preface, "We have all loved airplanes, and the sky in which they truly live. What else? We are all individuals, and we have all put ourselves on the line—and we did it for God, country, and the thrill of it all."

The book included an informative essay by friend (and WASP) Dora Dougherty Strother and Noggle's "Remembrance," a captivating explication of her "wild-ass" life learning to fly, meeting bootleggers, buzzing cows, and other "naughty thrills."[49] The images that follow are pure Noggle: straight black-and-white portraits from full-figure to three-quarter shots of the women, some in uniform, others with their wings pinned to civilian shirts. Her unsentimental candor continues with frontal forms strongly lit against dark backdrops, accenting personality, individuality, the lines in their faces and hands. Most are relaxed and smiling, some are playful and amused, others appear more serious and somber, a few look dazed, and many stand proudly erect. Noggle herself is pictured oddly akimbo, her torso and feet moving in different directions, her badge and wings pinned to her shirt, blending seamlessly with her cohorts.

Reviews were not always favorable. In her interview with Tucker, Noggle shared words from *The Virginia Review* (by an unnamed male reviewer): "This coffee-table tome is distinguished by its photographic evidence that feminine youth and beauty are brutally evanescent. The contrast between the exciting comeliness of the girls who fill the wartime snapshots and the misshapen hags and scarecrows whose portraits adorn the latter half of

the book should make many a young man contemplating marriage pause and reflect."[50] After reading this text, she added, "Talk about a bigot. . . . I thought they looked wonderful."

Noggle continued to document the lives of women pilots into the 1990s, now in her seventies and in the Soviet Union. With her friend and helper Jim Holbrook, plus a translator and sponsor, Noggle took six trips to Moscow, Kiev, and Leningrad from 1990 to 1992 to interview and photograph the Soviet Army Air Force veterans. It was a demanding assignment; during one trip she developed pneumonia. "I never had such determination to do anything in my life. What they went through in the war was so terrible and yet so noble. It created these wondrous faces of people who have seen an awful lot, lived through it, and now feel good about who they are and what they've done. I photographed and interviewed sixty-nine women. Nine of them were Heroes of the Soviet Union, which is their nation's highest award."[51] (See portfolio IV.)

Unlike WASPs, Soviet women flew combat missions just like their male counterparts. They were sometimes disparaged as "army whores, military bitches," and Nazi Germans nicknamed them "night witches," for forcing troops to stay awake and on alert. Noggle summarized, "They flew combat for three and a half years, or more. I have nothing but awe and admiration for them."[52]

A Dance with Death: Soviet Airwomen in World War II was published in 1994 with an introduction by Christine White, transcriptions of the women's stories, preface and coda by Noggle, and the portraits in the back of the book. Again, the photos of these women are black and white, in typical portrait styles, with backdrops; some sitters are in uniform, others in civilian dress. All convey a refreshing variety of idiosyncratic looks, gestures, and personalities.

As with the WASP portraits, her images of the Russian pilots reflect, as her friend Martha Strawn put it, "her personal in-depth love for those women who shared her experiences. She felt soft for them, celebrated them for their guts and strength and their perseverance. She was delighted with their quirks as they aged. Plus she was proud of what she and they had done."[53]

The book itself is challenging; the photos are low-quality reproductions and the texts are not matched to the portraits, so the photographs float in the back, divorced from the stories of the women portrayed. (There are no notes and no index). Many of the reviewers were non-art sources such as military historians, appreciative of her recounting stories of "unsung heroines."[54] While Noggle was not a traditional historian, she initiated a significant reclamation of these women's neglected histories. And as with her previous book, Noggle entered a multi-disciplinary territory—not quite art, not quite academic history, but something in between. Perhaps she was more postmodern than she knew.

Over her lifetime, Noggle captured an engrossing variety of sitters in a direct manner that spoke to age, gender, and character with, as she called it, "customary Noggle

bite."[55] But her remarks in *Silver Lining* perhaps speak most deeply to her photographic endeavors, from the portraits of her mother and friends, to couples in Texas and Seattle, old WASPs, Russians, and herself:

> I hope that all of my images have or hold in some sense the heroics of confronting life—I hope I speak more of immortality, of humanness and that our limited spans on this planet are notable. I'm trying to humanize the middle-aged and older, to find a new perspective that does more than simply deny older persons and let them be a viable part of society. I cannot view life as a tragedy alone—certainly what sees you through is humor and recognition of the banality of the whole time-span and the nobility of it too.[56]

NOTES

Foreword: "Wild-Ass" Messages from Within by Lucy R. Lippard

1. Noggle, *For God, Country, and the Thrill of It*, p. 56.

2. Noggle quoted in Janice Zita Grover, "Anne Noggle's Saga of the Fallen Flesh," p. 9.

3. Ibid., p. 6.

4. Ibid., p. 16.

5. *"Remember Me," A Documentary of Anne Noggle*, produced by Sue A. Gradisar.

6. August Sanders's dispassionate portraits were another influence.

7. Grover, p. 14.

8. Ibid., p. 15

9. Ibid., p. 16.

10. Ibid., p. 18.

11. *"Remember Me."*

12. Grover, p. 22.

13. *"Remember Me."*

14. May Stevens, "No One Looks Closer," p. 15.

15. In New Mexico, she befriended many artists and photographers, including the respected elder Laura Gilpin and Patrick Nagatani, a former colleague at UNM, whose 2017 book *The Race: Tales in Flight*, a fictionalized account of women pilots, acknowledged Noggle's help.

"The Thrill of It All": A Portrait of Anne Noggle by Lili Corbus

1. Graham Clarke, *The Photograph*, p. 102.

2. Noggle, *For God, Country, and the Thrill of It*, p. ix.

3. Noggle, *Silver Lining*, p. 29. "She had two half lungs as a result of her barnstorming days when she was crop dusting fields with chemicals" (Lynn Davis, email, 12/21/17); also see Miller, "She Flew Solo."

4. Noggle, *Silver Lining*, p. 30. Noggle also observed, "There is a resemblance, I think, between flying and photography. Both are done alone, in concept anyway, and both require independence and optimism, and some dumb courage" (Grover, p. 9).

5. Anne Noggle Foundation, Miscellaneous Materials (Noggle résumé and appraisal report biography). Surprisingly, given Noggle's accolades, her appearance in primary texts is spotty; in a quick review of my own library, she is missing from the *Encyclopedia of Twentieth-Century Photography*, *Photography: A Cultural History*, *Seizing the Light: A History of Photography*, and *Photography: A Critical Introduction*, but she does make a brief appearance in Naomi Rosenblum's *A World History of Photography*.

6. Grover, pp. 10, 12.

7. At the time, Noggle sought emotional detachment from her subjects, but that tactic didn't work well; she became conscious of the difficulties the subjects faced and never exhibited the series (Christine H. Kirk-Kuwaye, "Exceptional Moments," p. 111). Her once-student and friend Lynn Davis explained to me that "she didn't feel it was part of her mature work," it just "didn't really represent her" (phone interview, 5/25/18).

8. Grover, p. 12. Perhaps Noggle's most explicit homage to Cameron is found in two photos entitled *Two Graces* (dates unknown). They are nearly absurd re-creations of Greco-Roman figure groupings, played out by her friend Nancy Barry and another (unidentified) sitter, both draped in diaphanous white sheaths (ANF, Misc. Materials, inventory). Nancy, apparently Noggle's partner for some years, appears frequently in her photos of the 1970s—nude, in male clothing, and in other situations. Noggle was not open about her romantic relationships with women. Placing her within a lesbian context is territory no one has explored in depth, though Miller's article mentions it. Kirk-Kuwaye calls Noggle's images "unconventional, disruptive, disturbing, and queer" (p. 171).

9. "Rather like a polished repertory company, this small cast of characters appears and reappears in Noggle's work" (Grover, p. 15). Grover's essay in *Silver Lining* provides insightful analyses of Noggle's "distinctive and revelatory body of work" (p. 6).

10. Barthes, *Camera Lucida*, pp. 66, 94.

11. Grover, p. 20. Grover added (as if surprised that the aged continue to grow?), "The human personality, even under the stress and fray of aging, still expands and flows, still is capable of change and surprise" (p. 21). Estelle Jussim, *The Eternal Moment*, p. 57.

12. Davis, email, 12/21/17.

13. Sam Atwood, "The Dream of Cason del Triunfo Lives On." Davis also shared snapshots and personal letters with me.

14. Abigail Solomon-Godeau quoted in Kirk-Kuwaye, p. 94; Kirk-Kuwaye provides an excellent discussion of Yolanda as subject (pp. 76–82).

15. Davis, email, 12/22/17. Noggle would lose her companionship, too, in 1988, when Shelley died at age seventy-six. "Marjorie Shellenberger," obituary.

16. Noggle recalled being "afraid" of her own great-grandmother and noticed she was excluded from conversations. "Now, I wonder, 'My God, what could she have been thinking?' How alone she must have felt." Tucker and Noggle, "Anne Noggle," p. 59. As Barrow observed (and many others have substantiated), "she felt that when women got to a certain age, they became unseen and unheard" (Elaine Woo, "Anne Noggle," 83). In contrast, Noggle found "young faces a tabula rasa, nothing is written there. They are empty until they reach their 40s. Then they become photographable" (Christopher Hawtree, "Anne Noggle").

17. Noggle also curated a retrospective of Gilpin's work, "a labor of love" (Katherine Ware, "Pictures of an Evolution").

18. Noggle's series entitled *Silver Lining* focused on couples, conveying a variety of moods, from discordant to playful, detached to affectionate, to show "life together is and isn't a bowl of cherries," as Noggle put it (Grover, pp. 22–23). Her book *Silver Lining* includes work from all of these trips, to the UK, Texas, and Seattle.

19. Noggle, letter to Lynn Davis, 9/1/85. Noggle translated the Latin phrase as "Thus Passes the Glory of Yourself," also using it as a subtitle to one of Yolanda's portraits (1983).

20. Sue A. Gradisar, *Remember Me*; Elsa Dorfman, "New Wrinkles," p. 13.

21. ANF, Misc. Materials (Inventory) and Miller. Bullock's photo figured prominently in *The Family of Man* exhibit, 1955.

22. Miller, quoting a museum lecture of 1986.

23. Tucker and Noggle, p. 59.

24. Noggle was reading *The Hero Within: Six Archetypes We Live By*, by Carol Pearson (Kirk-Kuwaye, p. 183). The title was inspired by a popular romantic song of 1944.

25. Kirk-Kuwaye, pp. 177, 179. Hawtree wrote in *The Guardian* that Noggle is not unlike "a naked Dame Edna Everage" (a campy British cross-dressing comedian). Noggle's image of aged coquette Edith "Tiny" Keene (1981), with her beach ball in hand (see p. 63), also comes to mind (subtitled *Youthenasia* in ANF, Misc. Materials, Inventory).

26. Joanna Frueh, "The Erotic as Social Security," pp. 66, 69. Other images complement Frueh's analysis, such as Noggle's aged odalisque *Ruth Leakey*, 1980, and Noggle herself reclining as *Olympia* (no date; ANF, Misc. Materials, Inventory).

27. Noggle finally got "sick of it," the preoccupation with her facelift photos (Grover, p. 17).

28. Grover, p. 16; Tucker and Noggle, p. 59.

29. Kirk-Kuwaye, p. 112. "Noggle recalled saying, 'This is one surgery I'm going to love.'" More on her lung surgeries is found in Miller.

30. Van Deren Coke, foreword to Noggle's *Silver Lining*, p. ix. Noggle wrote, "I could tell you all about the changes the body goes through at forty, fifty, sixty. Sometimes I'll lie in bed at night and hold up my arm and stare at the way the skin falls away from it and I'll think, Hmmm. . . . it's gravity seeking gravity, the something in us that wants to die" (Grover, p. 25).

31. Noggle, "Seeing Ourselves," pp. 31–32.

32. Davis, letter from Noggle, 9/89, and "Autobiography" ("zit" quote).

33. Grover, p. 24.

34. James Kaufmann, "Sympathetic but unsparing photographs." Dana Asbury, "Shows We've Seen," pp. 62, 111. To be fair, Asbury added that "if her view is unflinching, it is never unkind, based as it is upon shared experience. A certain barbed wit also saves the work from even approaching the sentimental. . . . Her honesty is neither flattering nor pretty, but it scratches the surface off appearances and reveals a commonality among mortals" (p. 111). Ron Geibert also thought that Emmet Gowin, featured in the same exhibit, turned his mother-in-law into a "timeless megalithic ruin." A newspaper headline proclaimed that a show Noggle was in "Dares to Denude Bodies Well Past Their So-Called Prime," while the reviewer wrote, "These nudes are not only quite nude, they're OLD. Keep the children and lusty preconceptions at home" (Josef Woodward, "The Art of Aging"; he does go on to appreciate the "potent" group show). An entry on "Feminist Photography" even brought undesirability into focus by noting that Noggle, unlike Dater, "turned her lens to less fashionable and not-so-sexy middle-aged subjects" (McCarroll, pp. 507–8).

35. "Anne Noggle," obituary, *The Telegraph*. Tucker and Noggle, pp. 59–60. Davis, "Autobiography." Noggle also noted, "People automatically see wrinkles and think 'addled'" (Dorfman, p. 13).

36. *Women and Aging: An Anthology by Women*, pp. 34, 36 (Noggle's entire portfolio: 34–39). Also see Noggle, on "credo," in "Seeing Ourselves," p. 30. Cunningham approached age "without fear, without condescension, but with self-identification and compassion" (Margaretta Mitchell, quoted in Alexander et al., *Women and Aging*, p. 26).

37. Barbara McDonald, "Outside the Sisterhood," pp. 20–21; Baba Copper, "Voices," pp. 47–48. Yet another contributor to *Women and Aging*, Shevy Healey ("Growing to Be an Old Woman: Aging and Ageism," pp. 58–62) attempted to bring strong virtues to aging: "To face the challenge of dying with grace—that is power" (p. 62).

38. Tucker and Noggle, p. 59.

39. Charlotte Streifer Rubenstein, *American Women Artists*, pp. 374–75.

40. Joyce Tenneson Cohen, *In/Sights,* p. vi. Photographer Jo Spence documented her mastectomy, raising awareness of breast cancer (1982). As was often noted at the time, "the personal is political."

41. Kirk-Kuwaye, pp. xii, xiv, 22, 65. Kirk-Kuwaye provides an excellent discussion on this subject; she calls Noggle's works "feminist" in that they portray "strong independent individuals, complex and unconventional, with humor, irony, and tension" (pp. 65–66). Ware said Noggle was "not talking the liberated talk. [But] she was living it before the movement started" (Miller, n.p.). Dorfman wrote "[Noggle] does not describe herself as a feminist. She rejects the suggestion that a collection of images is inherently political" (p. 14). Davis believes "labels like that did not suit her" (phone interview, 5/25/18). Noggle resisted (as Georgia O'Keeffe had) being boxed, defined, and marginalized as "woman," a complex ideological position deserving a larger conversation elsewhere.

42. Tucker and Noggle, p. 59.

43. Asbury, *Self as Subject,* p. 4.

44. In conversations with Kirk-Kuwaye, Noggle called postmodernism "a lot of shit," "a vampire of life"; she believed photos were far more than "mere simulacrums" (pp. 211–12, 244).

45. Davis, phone interview, 5/25/18; Kirk-Kuwaye, p. 205.

46. Davis, phone interview, 5/25/18.

47. Out of over 25,000 applicants, Noggle was one of the 1,074 volunteers chosen to become a WASP. Each earned $250 a month (less than men in similar positions). Once demobilized in December 1944, WASPs were sent back to civilian life with no benefits, to make room for returning male pilots. In 1949 the Air Force offered commissions to former WASPs, which is how Noggle returned to active duty during the Korean War, eventually earning Captain status. Finally, in 1977 the Air Force was authorized by Congress to recognize WASP as military service, worthy of veterans' benefits (Dora

Dougherty Strother, "Women of the WASP," p. 14). Women were not formally trained for military flight again until 1976, during the Gulf War. By 2009, after Noggle's death, all WASPs were awarded Congressional Gold Medals. It was only in 2016 that it was decided WASPs could be buried at Arlington National Cemetery.

48. Noggle, "Remembrance," p. 63.

49. Ibid., p. 57. In the acknowledgments, Noggle noted that her "45 year old memory" was "smudged by the haze of time, made apocryphal by the vagaries of clogged arteries, distorted perhaps by personal vanity, yet true in its essence, in its spirit" (p. xi).

50. Tucker and Noggle, p. 60. Many of the book's reviews came from non-art disciplines as the subject matter attracted broader attention. Looking back, one wonders if the reception of her portraits of patriotic women in the Air Force may have been clouded by the times. The year her book was published, the United States began Operation Desert Shield, a controversial and contested military response to Saddam Hussein's invasion of Kuwait.

51. Ibid.

52. The Russian female pilots faced the enormous difficulty of "reconciling conventional femininity with killing and fighting" (Liza Mundy, "Forgotten Women on the Front Lines of World War II"); Tucker and Noggle, p. 60. Noggle even helped raise money for their medical care by selling photos ("Anne Noggle," obituary, *The Telegraph*). Noggle's travels coincided with the collapse of the Soviet Union in 1991. Interestingly, in one of Noggle's photos (of herself, scowling, 1989), *End of the Party* (the Communist Party?), her middle finger appears pointed—an accident or a reflection of her mood given current events? (See p. 115.)

53. Strawn, email, 5/25/18.

54. "What Readers Are Saying."

55. Davis, letter from Noggle, 7/3/89.

56. Grover, p. 27.

ACKNOWLEDGMENTS

I am most grateful to the Anne Noggle Foundation (ANF) for the opportunity to make this book. Foundation board members are Lynn Davis, Elizabeth Hadas, James Collins Moore, John Mulvany, and I. Together we have worked to distribute Anne Noggle's work as stated in the goals we set forth for the ANF at its inception in 2007. I am also grateful to the Harry Ransom Research Center (HRC) at the University of Texas at Austin for housing the Anne Noggle Archive and for continuing to work so cooperatively with the ANF. I am especially appreciative of the assistance of Mary Alice Harper, who was a major partner in the transfer of the Anne Noggle archive materials to the HRC.

As I set about editing this book, I asked Lucy R. Lippard and Lili Corbus on behalf of the ANF to write essays, and both enthusiastically lent their skills and wisdom to this project. Again, I deeply appreciate all their hard work and rich results. For publishing advice and administrative work I am grateful to Elizabeth Hadas, but most of all I value her role as copy editor and sounding board for this book's contents. I thank Lynn Davis for tidbits of information ferreted out of historical papers and emails and more. Lili, Lynn, and I together developed a chronology of Anne's life from numerous sources. This project was a real team effort!

Of course, we are most grateful to the Museum of New Mexico Press for publishing this book in association with the Anne Noggle Foundation and Harry Ransom Center. They truly are making the production of this book possible. I am also delighted that David Skolkin designed this book. I have worked with David before, and he is a superlative designer with gracious and excellent communication skills.

The selection of images benefited from a strong support group of reviewers: Lili Corbus and Elayne Dubin both provided insightful critical opinions. The Light Factory Museum of Photography and Film generously provided meeting space, and Kay Tuttle and Laurie Schorr acted as a sounding board for the manuscript review. Dick Eaker, Jean Dutterer, Jane Ward, and Patricia Ehrhardt contributed by working with me to assemble twin manuscript mockups. My husband, Bill Latham, took over chores at home and lent his patience for the time it took to do this project. I am eternally grateful to each and every one of these participants. Their contributions made this book possible.

ABOUT THE CRAFT

ANNE NOGGLE primarily used Nikon F series 35mm cameras with Nikkor lenses. When making self-portraits, she often used timers, or she equipped her cameras with remote release buttons, and she sometimes worked with assistants. Anne primarily used Kodak Tri-X and Plus-X films, and her archives indicate that she also occasionally used Ilford ISO 125 and 400 films. She printed on Kodak and Ilford double-weight papers. Most of her prints were monochromes. However, she did produce a series of color images during her career. While these chromatic images included some powerful and vibrant statements, they were not a major part of her larger body of work.

ABOUT THE ANNE NOGGLE FOUNDATION

The Anne Noggle Foundation (ANF) is a nonprofit corporation established in 2007 in the state of New Mexico. The foundation operates solely for the purposes of promoting the artistic qualities of Anne Noggle's creative endeavors and is in accordance with all laws and ordinances that regulate such nonprofit organizations.

The foundation placed Anne Noggle's complete archive at the Harry Ransom Research Center at the University of Texas at Austin, where researchers may obtain access to her work. The foundation owns the remaining collection of Anne Noggle's work. From this collection the foundation has distributed Anne Noggle's photographs to the Harn Museum of Art at the University of Florida, Gainesville, Florida; the Davis Museum at Wellesley College, Wellesley, Massachusetts; the New Mexico Museum of Art, Santa Fe, New Mexico; and the Museum of Texas Tech University, Lubbock, Texas. The foundation donates all works and charges only for processing and shipping.

A primary goal of the foundation is to produce an informative book on the major sections of Anne Noggle's creative endeavors. It is our sincere hope that further work will follow that examines the full extent of her works and more thoroughly establishes the importance of her photographic expressions.

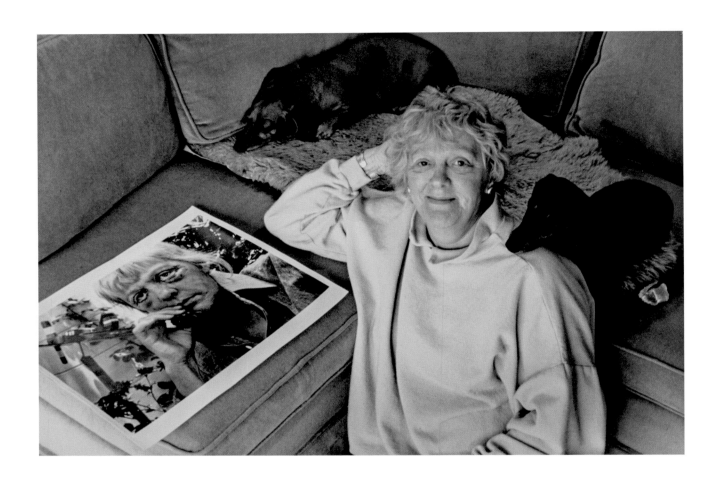

SELF-PORTRAIT, 1979

150

CHRONOLOGY OF THE LIFE AND CAREER OF ANNE NOGGLE

Martha A. Strawn, Lili Corbus, and Lynn Davis

1922	Born August 16 in Evanston, Illinois
1939	Begins flying lessons at age 17
1940	Licensed pilot at age 18
1943	Trains for Women Airforce Service Pilots (WASP), Sweetwater, Texas
1944	Graduates in WASP Class of 1944
1945	Leaves WASP with commercial pilot's license
1945–53	Stunt performer in aerial circus (age 25)
	Crop duster in the American Southwest, resulting in damaged lungs (age 26)
	Flight instructor
1953–59	Captain in US Air Force (age 31–37). Enters active duty June 1953 with direct commission as first lieutenant and serves at bases in Louisiana, North Carolina, and Montana and at Tinker Air Force Base, Oklahoma. Intercept controller during Korean War. In 1958 in Paris, France, with Air Force. Returns to United States and is diagnosed with pneumonia.
1958	Undergoes lung surgeries, after which she is no longer able to fly
1959	Retires from the US Air Force with disability status
	Moves to Albuquerque, New Mexico
1959–60	Studies art history as an uwergraduate at the University of New Mexico on GI Bill
1965	Begins to photograph

1966	Graduates with BA in art history from University of New Mexico
	Enrolls in Master of Arts graduate program at UNM
1969	Graduates with MA in art with an emphasis in photography
1970	First solo exhibition, One Loose Eye Gallery, Taos, NM (age 48)
	Awarded first place in Central Pennsylvania Festival for the Arts, juried by Diane Arbus
1970–76	Curator of photography, Museum of New Mexico in Santa Fe
1970–84	Adjunct professor of art, UNM
1971	Solo exhibition at Friends of Photography Gallery, Carmel, California
1975	Co-curates *Women in Photography: An Historical Survey* with Margery Mann
	Awarded first National Endowment for the Arts (NEA) fellowship in photography Begins *Facelift Series* (age 53)
1977	*Stonehenge Decoded*
1977–81	Serves on the national Society for Photographic Education Board of Directors
1978	Awarded second NEA fellowship
	Begins *Silver Lining Series*
	Hot Flash Series
	Photographs in United Kingdom
1979	Begins *Earth Bound Series*
1980	Exhibition, *Photographs by Anne Noggle*, San Francisco Museum of Modern Art
	Death of her mother, Agnes Noggle, on January 5
1981–83	Participates in New Mexico Survey: portraits of people living in New Mexico
1982	Awarded John Simon Guggenheim Fellowship
	Begins *Seattle Faces Series*
1983	*Silver Lining: Photographs by Anne Noggle* published by the University of New Mexico Press, Albuquerque
	Death of Yolanda Belloli on January 1
	Documentary film: *"Remember Me," A Documentary of Anne Noggle*, produced by Sue A. Gradisar at Mediadesigns, Albuquerque
1984	Last year at UNM as adjunct professor
1985	*Anne Noggle: A Retrospective Exhibition*, University of New Mexico Art Museum
1986	*Stella by Starlight Series*
	Women Airforce Service Pilot (WASP) portraits

1987	*Recent Follies Series* (video stills, *Past Time, Madame X*)
	Death of Marjorie Shellenberger (Shelley) in November
1988	Awarded third NEA fellowship
1990	*For God, Country, and the Thrill of It: Women Airforce Service Pilots in World War II* published by Texas A&M University Press, College Station. WASP exhibition of these portraits traveled to fourteen venues over the next four years.
	Documentary film *Anne Noggle: Capturing the Character of Aging*, produced by Sandy Garritano, *¡COLORES!* #116, New Mexico PBS (KNME), Albuquerque
	Travels to Soviet Union in the fall
1991	Returns to Soviet Union (now Russia) in December to photograph Soviet airwomen who served in World War II
	Awarded honorary doctorate of arts from the University of New Mexico
1992	Photographic trip to Russia
1994	*A Dance with Death: Soviet Airwomen in World War II* published by Texas A&M University, College Station
2004	Death of Mary Pease (Anne's sister) in Santa Fe on May 5
2005	Dies on August 16 at her home in Albuquerque

NOTE ON SOURCES

This chronology was compiled from records taken from Anne's résumé, notes from her papers, emails and personal correspondence with friends and colleagues, dates noted in her books, and dates noted in the inventory of her works made upon her death. We also queried the University of New Mexico and the Society for Photographic Education to verify dates. Any inconsistencies or omissions found by readers of this book should be considered with further research at the Harry Ransom Center, University of Texas at Austin, where her complete archive is located and is being processed.

Alexander, Jo, Debi Berrow, Lisa Domitrovich, Margarita Donnelly, and Cheryl McLean, eds. *Women and Aging: An Anthology by Women.* Corvallis, OR: Calyx Books, 1986.

"Anne Noggle." Obituary. *The Telegraph* (London, England), Sept. 15, 2005.

Anne Noggle Foundation. Miscellaneous Materials: Anne Noggle résumé, inventory, and appraisal report biography (Lorraine Anne Davis Fine Art Photography Appraisals LLC, Anne Noggle Estate, 2006).

Asbury, Dana. *Self as Subject: Visual Diaries by 14 Photographers.* Albuquerque: University Art Museum, 1983–88.

―――. "Shows We've Seen." *Popular Photography* 89, no. 2 (February 1982): 62, 111.

Atwood, Sam. "The Dream of Cason del Triunfo Lives On." *Santa Fe New Mexican*, May 23, 1986.

Barthes, Roland. *Camera Lucida: Reflections on Photography.* Translated by Richard Howard. New York: Hill and Wang, 1981.

Clarke, Graham. *The Photograph.* Oxford and New York: Oxford University Press, 1997.

Cohen, Joyce Tenneson. *In/Sights: Self-Portrait by Women.* Boston: David R. Godine, 1978.

Coke, Van Deren. Foreword in Noggle, *Silver Lining: Photographs by Anne Noggle*, pp. ix–x. Albuquerque: University of New Mexico Press, 1983.

Copper, Baba. "Voices: On Becoming Old Women." In *Women and Aging: An Anthology by Women,* edited by Jo Alexander et al., pp. 47–57. Corvallis, OR: Calyx Books, 1986.

Dorfman, Elsa. "New Wrinkles." *The Women's Review of Books* 2, no. 6 (1985): 13–14.

Frueh, Joanna. "The Erotic as Social Security." *Art Journal* 53, no. 1, Art and Old Age (Spring 1994): 66–72.

Garritano, Sandy, producer. *Anne Noggle: Capturing the Character of Aging.* ¡COLORES! #116. Documentary film. Albuquerque: New Mexico PBS.

Geibert, Ron. *Family Portraits*. Dayton, OH: Wright State University, 1987. Unpaginated.

Gradisar, Sue A., producer. *"Remember Me," A Documentary of Anne Noggle*. Documentary film. Albuquerque, NM: Mediadesigns, 1983.

Grover, Janice Zita. "Anne Noggle's Saga of the Fallen Flesh." In Noggle, *Silver Lining: Photographs by Anne Noggle*, pp. 5–27. Albuquerque: University of New Mexico Press, 1983.

Hawtree, Christopher. "Anne Noggle." Obituary. *The Guardian*, Sept. 14, 2005.

Healey, Shevy. "Growing to Be an Old Woman: Aging and Ageism." In *Women and Aging: An Anthology by Women*, edited by Jo Alexander et al., pp. 58–62. Corvallis, OR: Calyx Books, 1986.

Jussim, Estelle. *The Eternal Moment: Essays on the Photographic Image*. New York: Aperture Press, 1989.

———. "The Psychological Portrait." In *Karsh: The Art of the Portrait*, edited by James W. Borcoman, pp. 87–112. Ottawa: National Gallery of Canada, 1989.

Kaufmann, James. "Sympathetic but unsparing photographs." Review of *Silver Lining*. *Christian Science Monitor*, April 20, 1984.

Kirk-Kuwaye, Christine H. "Exceptional Moments: A Feminist Analysis of Selected Images of the Photographic Work of Anne Noggle." PhD diss., University of Hawaii, 1999.

"Marjorie Shellenberger." Obituary. *Albuquerque Journal*, Sept. 27, 1988.

McCarroll, Stacey. "Feminist Photography." In *Encyclopedia of Twentieth-Century Photography*, volume 1, edited by Lynn Warren, pp. 507–511. New York and London: Routledge, Taylor and Francis Group, 2006.

McDonald, Barbara. "Outside the Sisterhood: Ageism in Women's Studies." In *Women and Aging: An Anthology by Women*, edited by Jo Alexander et al., pp. 20–25. Corvallis, OR: Calyx Books, 1986.

Miller, Elizabeth. "She Flew Solo: Photographer Anne Noggle takes flight in museum retrospective." *Santa Fe Reporter*, March 29, 2016.

Mundy, Liza. "Forgotten Women on the Front Lines of World War II." Review of *The Unwomanly Face of War: An Oral History of Women in World War II*, by Svetlana Alexievich. *Washington Post* (Book World section), Aug. 6, 2017.

Nagatani, Patrick. *The Race: Tales in Flight*. Albuquerque: Fresco Books, 2017.

Noggle, Anne. *Silver Lining: Photographs by Anne Noggle*. Albuquerque: University of New Mexico Press, 1983.

———. "Seeing Ourselves (From a Speech Delivered to the Class of 1983, Portland School of Art, Maine)." In *Silver Lining: Photographs by Anne Noggle*, pp. 29–33. Albuquerque: University of New Mexico Press, 1983.

———. "Remembrance." In *For God, Country, and the Thrill of It: Women Airforce Service Pilots in World War II*, pp. 55–63. College Station: Texas A&M University Press, 1990.

———. *A Dance with Death: Soviet Airwomen in World War II*. Introduction by Christine A. White. College Station: Texas A&M University Press, 1994.

———. *A Sense of Self: Photographic Self-Portraits by Anne Noggle*. Introduction by Peter Walch. Catalog of an exhibition at University of New Mexico Art Museum, Jan. 18–March 5, 2000. Albuquerque: University of New Mexico Art Museum, 1999.

Noggle, Anne, and Margery Mann. *Women of Photography: An Historical Survey*. San Francisco: San Francisco Museum of Art, 1975.

Rubenstein, Charlotte Streifer. *American Women Artists*. New York: Avon Books, 1982.

Stevens, May. "No One Looks Closer." In *Bailey Doogan: Selected Works, 1971–2005*, edited by Julie Sasse, pp. 15–16. Catalog of an exhibition held at Tucson Museum of Art, Tucson, Sept. 10, 2005–Feb. 12, 2006, and at Etherton Gallery, Tucson, Nov. 8, 2005–Feb. 18, 2006. Tucson: Etherton Gallery, 2006.

Strother, Dora Dougherty. "Women of the WASP: An Introduction." In Noggle, *For God, Country, and the Thrill of It: Women Airforce Service Pilots in World War II*, pp. 3–15. College Station: Texas A&M University Press, 1990.

Tucker, Anne Wilkes, and Anne Noggle. "Anne Noggle." Interview. *Art Journal* 53, no. 1 (1994): 59–60.

Ware, Katherine. "Pictures of an Evolution: Photography's ever-developing presence at the New Mexico Museum of Art." *El Palacio Magazine* (Winter 2017): 27–35.

"What Readers Are Saying." Reviews of *A Dance with Death: Soviet Airwomen in WWII*. Texas A&M University Press website. Accessed June 7, 2018. http://www.tamupress.com/product/Dance-with-Death,1278.aspx.

Woo, Elaine. "Anne Noggle, 83: Photographed Older Women." Obituary. *Los Angeles Times* Sept. 4, 2005.

Woodward, Josef. "The Art of Aging: Santa Barbara show dares to denude bodies well past their so-called primes." *Los Angeles Times* (Ventura Co. edition), Dec. 18, 1997.

MARTHA A. STRAWN was born in Washington, DC, in 1945. She grew up in Lake Wales, Florida, and now resides near High Springs, Florida, and near Tryon, North Carolina. She received her BA from Florida State University, her Basic Certificate from Brooks Institute of Photography in Santa Barbara, California, and her MFA from Ohio University in Athens, Ohio.

Professor of art emerita at the University of North Carolina in Charlotte, Strawn has long been recognized for combining aesthetic and scientific inquiries into the study of place that she calls *visual ecology*. She co-founded the Light Factory Contemporary Museum of Photography and Film in Charlotte and has served on the board of directors of the Society for Photographic Education, the Friends of Photography, the Center for the Study of Place, the Davidson Lands Conservancy, and Our Santa Fe River. She was a Fulbright Fellow to India and a National Endowment for the Arts Fellow in photography. Her photographs have been exhibited and are in collections worldwide, including the Indira Gandhi National Centre for the Arts, Smithsonian Institution, Princeton Art Museum, National Geographic Society Museum, Southeastern Center for Contemporary Art, Harry Ransom Center, The University of Texas at Austin, and Carnegie Museum of Natural History. She is the author of *Alligators, Prehistoric Presence in the American Landscape* (1997) and, with Yi-Fu Tuan, *Religion: From Place to Placelessness* (2009) and *Across the Threshold of India: Art, Women and Culture* (2016).

LUCY R. LIPPARD, American art writer, activist, feminist, and sometime curator was born in New York, New York, in 1937 and has lived in Galisteo, New Mexico, for twenty-five years. She has a BA from Smith College (1958) and an MA from New York University (1962), as well as several honorary doctorates. She began writing full-time in 1964 in *Art International, Artforum*, and other publications. Her contributions as activist, curator, and art critic are numerous, including setting a standard for what would later be regarded as process, or antiform art, in *Eccentric Abstraction*, an exhibition she curated at the Fischbach Gallery (1966). Her early and long-lasting involvement in conceptual art was documented

in her book *Six Years* (1973), later the subject of a Brooklyn Museum exhibition. Lippard was an active member of the Art Worker's Coalition, which resulted in vast changes in the art world; she co-founded the Ad Hoc Women Artists Committee, which succeeded in making museums pay attention to women's art, PADD (Political Art Documentation/ Distribution), Printed Matter, the Heresies Collective and journal, and Artists Call Against U.S. Intervention in Central America. Author of more than twenty books on contemporary art and an experimental novel, as well as three books on New Mexico history and archaeology, Lippard is an ardent advocate for marginal art of all kinds. Among her books are *From the Center: Feminist Essays on Women's Art* (1976), *Mixed Blessings: New Art in a Multicultural America* (1990), *The Lure of the Local* (1997), *On the Beaten Track: Tourism, Art, and Place* (1999), and most recently, *Undermining: A Wild Ride Through Land Use, Politics, and Art in the Changing West* (2014), which reflects her activism in local issues. She continues to seek out "social energies not yet recognized as art."

Lili Corbus grew up in Florida and now resides in Charlotte, North Carolina. She received her BA in anthropology from Kenyon College in Ohio and later, while raising her son, studied photography at the University of North Florida and American studies at Florida State University. She briefly freelanced for newspapers and worked as a wedding photographer before eventually earning an MA in American studies from University of Maryland, College Park, and a PhD in art history from the University of Texas at Austin. After teaching at Ohio University and the University of Montana, she taught at the University of North Carolina, Charlotte, where she retired as an emerita associate professor of art history in 2006. Her areas of specialization include the history of photography, modernism, and women in art. She has been widely published, including her book on the decline of social documentary ideals, *Photography and Politics in America: From the New Deal into the Cold War* (Johns Hopkins University Press, 1999). Topics of her articles and lectures range from women in the Photo League (Sonia Handelman Meyer, Rosalie Gwathmey, and Lisette Model), to photojournalist Louie Palu, wedding photography, and the photographs of Nina Leen, Robert Frank, and more. Having interviewed many artists over the years, she has also published articles about her experiences with John Cage and Aaron Siskind. Now an independent scholar, she continues to research, publish, lecture, and curate, often at the Light Factory in Charlotte, where she serves on the Exhibition Committee.

SOURCES FOR POEMS

"The Crop Duster" by Anne Noggle, ca. 1984–88. Emails from Lynn Davis to Martha A. Strawn, June 23, 2018, and July 14, 2018.

"Sketch for a self-portrait" by Anne Noggle, 1982. Anne Noggle Archives, Harry Ransom Center, University of Texas at Austin.

"Sky High" by Anne Noggle, 1970. Anne Noggle Archives, Harry Ransom Center, University of Texas at Austin.

"The Soft Whisper" by Anne Noggle, 2001. Anne Noggle Archives, Harry Ransom Center, University of Texas at Austin.

Published in association with the Anne Noggle Foundation and the Harry Ransom Center

© 2019 Anne Noggle Foundation and Harry Ransom Center, The University of Texas at Austin.
Text © Martha A. Strawn, Lili Corbus, and Lucy R. Lippard. *All rights reserved.* No part of this book may be reproduced in any form or by any means whatsoever without the express written consent of the publisher. The Museum of New Mexico Press is a division of the New Mexico Department of Cultural Affairs.

Director: Anna Gallegos
Editorial director: Lisa Pacheco
Art director and book designer: David Skolkin
Pre-Press: John Vokoun
Composition: Set in Centaur and Din
Manufactured in Singapore
10 9 8 7 6 5 4 3 2 1

Library of Congress Cataloging-in-Publication Data
Names: Noggle, Anne, 1922–2005, author, photographer. | Strawn, Martha A.,
 1945- editor. | Lippard, Lucy R., writer of foreword. | Corbus, Lili,
 writer of added commentary.
Title: Flight of spirit : the photographs of Anne Noggle / edited by Martha
 A. Strawn ; foreword by Lucy Lippard ; essay by Lili Corbus.
Description: Santa Fe : Museum of New Mexico Press, [2019] | Noggle's
 photographs and some of her writings. | Includes bibliographical
 references.
Identifiers: LCCN 2018050103 | ISBN 9780890136416 (hardcover : alk. paper)
Subjects: LCSH: Portrait photography--United States. | Noggle, Anne,
 1922–2005. | Photographers—United States—Biography. | Women air
 pilots—United States--Biography.
Classification: LCC TR680 .N628 2019 | DDC 770—dc23
LC record available at https://lccn.loc.gov/2018050103

ISBN 978-0-89013-641-6 hardcover

Museum of New Mexico Press
PO Box 2087
Santa Fe, New Mexico 87504
mnmpress.org

Photographs by Anne Noggle unless otherwise noted